City of
Westminster

This book is dedicated to my wife
Molly and our grandchildren
Maisie, Casper and Leo.

City of
Westminster

Photographs & Postcards
From the Archives of Judges of Hastings Ltd

Warren Grynberg

AMBERLEY

JUDGES

IN ASSOCIATION WITH JUDGE SAMPSON LTD.

First published 2016

Amberley Publishing
The Hill, Stroud, Gloucestershire, GL5 4EP
www.amberley-books.com

ISBN 978 1 4456 5508 6 (print)
ISBN 978 1 4456 5509 3 (ebook)

British Library Cataloguing in Publication Data.
A catalogue record for this book is available from the
British Library.

Typesetting by Amberley Publishing.
Printed in Great Britain.

INTRODUCTION

London is the largest capital city in Europe with a population of over 8 million people. Unknown to many, London is in fact more than one city. It is two very different cities. To the east is the City of London, the world's great financial centre, founded by the Romans 2,000 years ago.

The City of Westminster is 1,000 years old. It is a city of government, religion, royalty and much more besides. Visitors and tourists flock by the millions to Westminster to see the historic sites, go shopping and to eat and drink at the many restaurants, cafés and public houses that this fine city has to offer.

With more than forty theatres in Westminster alone, not including around 200 in the suburbs, we have more than any other capital city in the world. Not forgetting the many cinemas spread throughout the whole of London and its environs.

The majority of museums and art galleries have free admission to the public and there are many to choose from covering the whole spectrum of art, science, history and natural history, etc.

But it wasn't always like that. The City of Westminster, from the turn of the turn of the twentieth century, can now be seen through the photographs of Fred Judge who was affectionately nicknamed 'The Postcard Man'.

Fred, a professional photographer and entrepeneur, along with his then newly established company Judges of Hastings Ltd., produced many thousands of photographic images and transformed them into many thousands upon thousands of postcards.

ABOUT THE AUTHOR

I am privileged to live in London, the greatest city in the world. Having left college in the 1960s, my career took off in the design and production departments of blue-chip advertising agencies. I returned home from my travels abroad and was extremely fortunate to be offered work in the book publishing industry.

My initial interest in the history and topography of London came about much later, and in 1992 I applied to the Corporation of London for a place on their official guiding course. One year later I qualified as a City of London Guide-Lecturer.

Around this time I visited a London postcard fair and was thrown into the world of deltiology, or postcard collecting. Among my collection of photographic postcards are cards produced by Judges of Hastings Ltd., postcard manufacturers and printers. This obsession led me to build up a large collection of Judges London postcards. What I didn't know was that this collection would lead me to the publication of two books.

In 1995 my first book *The City of London in Historic Postcards*, now sadly out of print, was published. This introduced me to LBC 97.3fm, London's leading independent radio station. They asked me to join their team of local experts answering all sorts of questions from the public on their London phone-in history programmes. I enjoyed working with this team of well-known radio presenters and producers for many years.

In the meantime my publishing career took a sideways turn because I was head-hunted by a leading company of map and guidebook publishers, editing, proofreading and marketing guidebooks and maps. Fifteen years later things took a turn for the worse, or so I thought. I didn't know it then but this was the best thing that could have happened. The company were moving out of London, and being married with two small children I was not prepared to move with them. One door slammed shut and another opened. The chance of a lifetime was just around the corner.

I qualified to become a London Blue Badge tourist guide in 1997. Having completed two years of what seemed like endless studying, and two weeks of practical and written exams, I was awarded the London Blue Badge, which is recognised internationally as a benchmark of excellence in tourist guiding. I guide visitors by coach, on walking tours and conduct tours of historic houses, royal palaces, churches, abbeys and cathedrals.

Images of the City of London, my second book, was published in 2005 and became an instant success. First published in hard cover, it soon went into a second edition as a paperback.

2016 has brought me into contact with Amberley Publishing who are publishing two books of mine, allowing me to show off my collection of Judges London postcards.

First and foremost I regard myself as a hoarder and collector of London postcards, antiquarian maps and books about London's history. I am also a keen photographer, member of the British Guild of Tourist Guides, the Institute of Tourist Guiding, the City of London Guide-Lecturers Association, London Topographical Society and the Judges Postcard Study Group. I am a Freeman of the City of London and also sit as a Justice of the Peace. As a member of the Judges Postcard Study Group we research the work of Fred Judges, his photographs and postcards.

FRED JUDGE FRPS (1872–1950)

(FELLOW OF THE ROYAL SOCIETY OF PHOTOGRAPHY)

THE POSTCARD MAN

Fred Judge, affectionately known as 'The Postcard Man', was born in Wakefield, in the north of England, in 1872, at a time when photography, although in its infancy, was becoming popular. He first became attracted to photography in 1890 and took a serious interest in landscapes and night scenes. He regarded this as an art form, becoming famous within photographic circles for his production of real photographic postcards, their production and printing.

Fred and his family went on holiday to Hastings around 1900, then a small town, in the south of England. He had little idea of the impact he was to make on the world of postcard printing and publishing. He was a master with his camera, certainly an entrepreneur, and fell in love with the place so much that the family decided to live there. He bought an existing photographic business, which became known as Judge's Photo Stores.

Fred often rose early to photograph local landscapes to produce postcards; their quality was far superior to any postcard yet produced. He later bought larger premises to provide greater production facilities.

Fred came to London and began photographing the streets and buildings of the City of Westminster, the City of London and its environs. His first London photograph, entitled *The Embankment at Night*, became a raving success in 1909 and he then embarked on specialising on photographing night scenes.

The London series of postcards is the subject of this book of Westminster images. They are numbered 1 to 817 prefixed by the letter L, or LS if sketch scenes. Fred Judge photographed London views that were then reproduced into tens of thousands of postcards in sepia and black and white, and even redrew them or had them redrawn as sketches. In 1927 Fred built his factory where his postcards were, and still are, produced and printed.

The sketch scenes were a cheaper alternative than the sepia variety that were becoming outdated. After his death in 1950, artist employee William Henry Constantine, known to his friends as Harry, continued producing the sketch cards in colour, and examples of these are seen in the book; I have included my favourite cards, both photographs and pencil sketches. They are in no particular order so that with a turn of each page you will be pleasantly surprised.

From small beginnings Judges of Hastings Ltd. grew and expanded into the well-known and respected company that it is today. The first cards sold for 1*d*; as costs increased so did the prices. From over 80,000 negatives many millions of postcards were produced. In 1968 sepia and black-and-white postcards lost their popularity in favour of the high-quality colour ones produced by the company that still bears his name.

Fred was, unfortunately, injured during the Second World War by one of the last high-explosive bombs to fall on Hastings. He passed away in 1950 at the age of seventy-eight.

Further expansion of the company took place with the acquisition of Sampson Souvenirs, the country's leading importers and producers of souvenirs to the tourist market. In 2013 Sampson and Judges merged under new ownership to form Judge Sampson Limited.

The Judges Postcard Study Group has approximately forty members who collect Judges' cards. The group researches and pools information to create a database of the postcards produced.

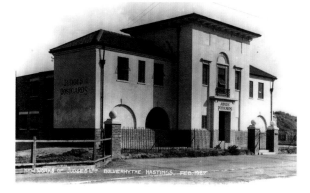

The new works of Judges Ltd, February 1927.

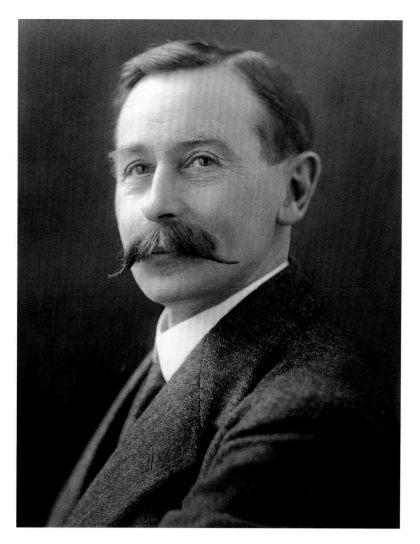

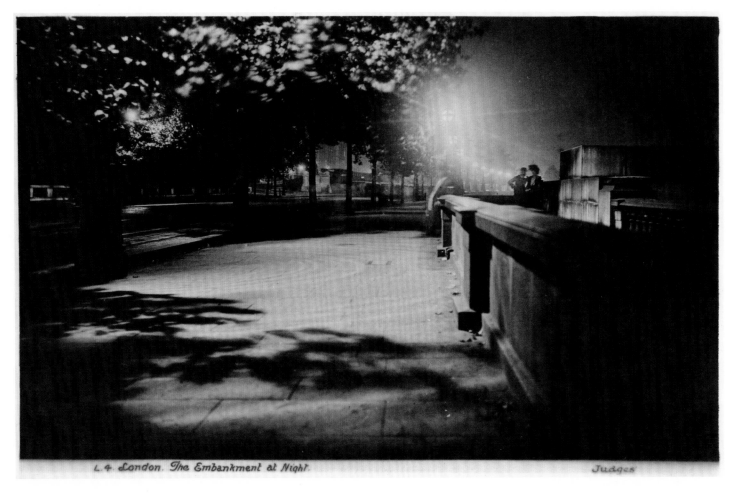

L.4 London. The Embankment at Night. Judges

This was the first of Fred Judge's London photographs produced as a postcard. Gas lamps light up the Victoria Embankment, which, in 1878, became the first street in Britain to be permanently lit by electricity. However ten years later gas lighting was re-established as electricity was too expensive.

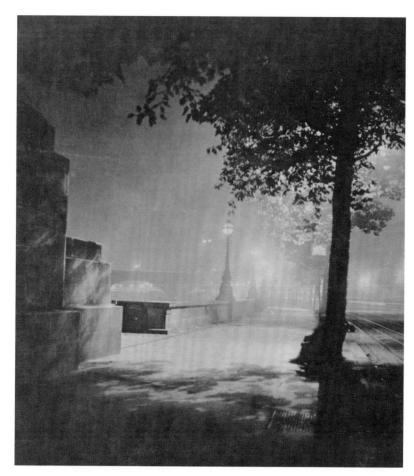

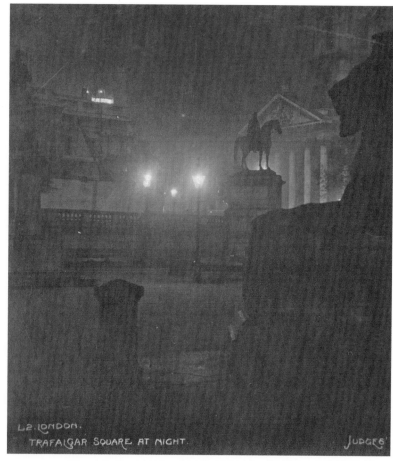

Waterloo Bridge in the distance, *c.* 1909. The bridge was damaged so severely during the Second World War that a new bridge was constructed in 1941; the work was done largely by women, hence its nickname, 'The Ladies Bridge'.

Trafalgar Square at night. In the distance is the Church of St Martin-in-the-Fields. The name is a reminder that there were once fields here and that this was countryside. The equestrian statue of George IV (the Prince Regent) is in the distance.

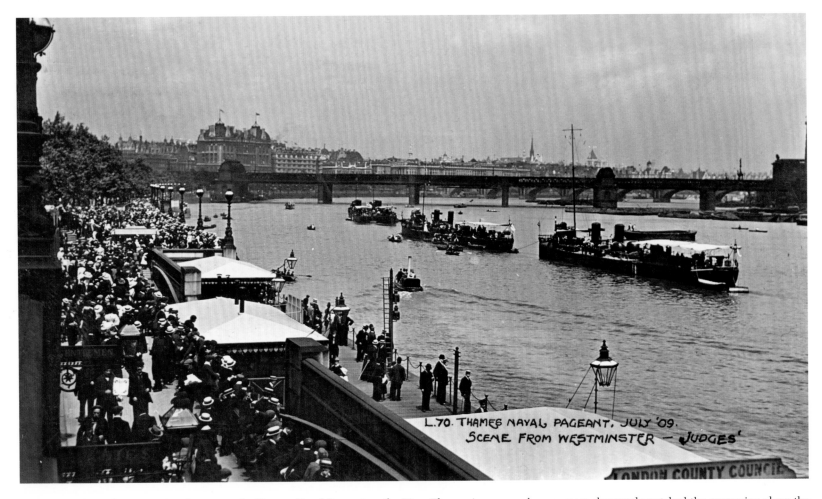

L.70. THAMES NAVAL PAGEANT, JULY '09.
SCENE FROM WESTMINSTER — JUDGES'

LONDON COUNTY COUNCIL

Thousands of people came to London to see the Thames Naval Pageant on the River Thames in 1909, and many more thousands watched the procession along the length of the river from the Thames Estuary in Essex to Westminster, a distance of approximately 50 miles.

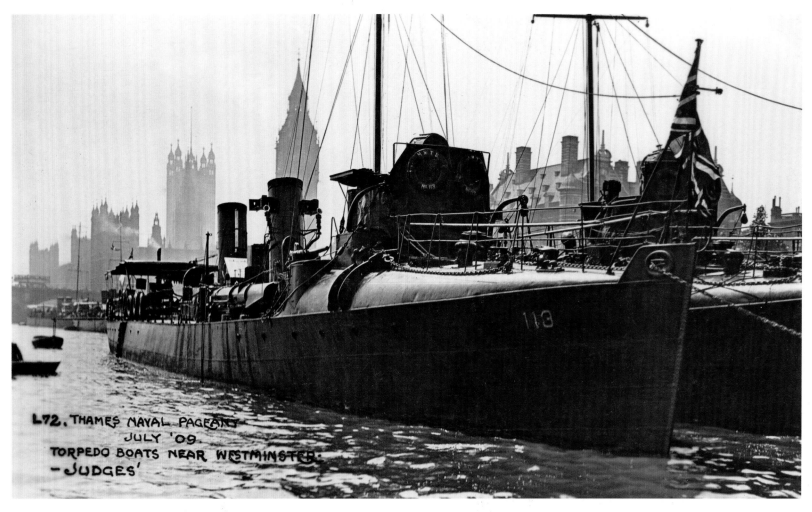

Torpedo boats anchored on the River Thames, 1909. The Elizabeth Tower, commonly but erroneously called Big Ben, and the Houses of Parliament can be seen in the distance.

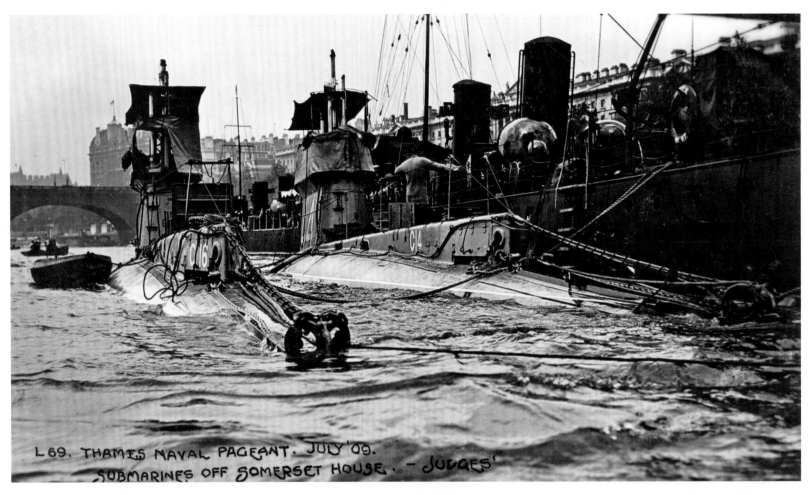

L 69. THAMES NAVAL PAGEANT. JULY '09.
SUBMARINES OFF SOMERSET HOUSE. - JUDGES'

The Thames Naval Pageant on the River Thames where newly built C-class submarines were on public display. The C14 was sunk in a collision off the coast of Plymouth in 1913, and the C16 was sunk by a German destroyer in 1917. Both were salvaged and put back into service until 1922.

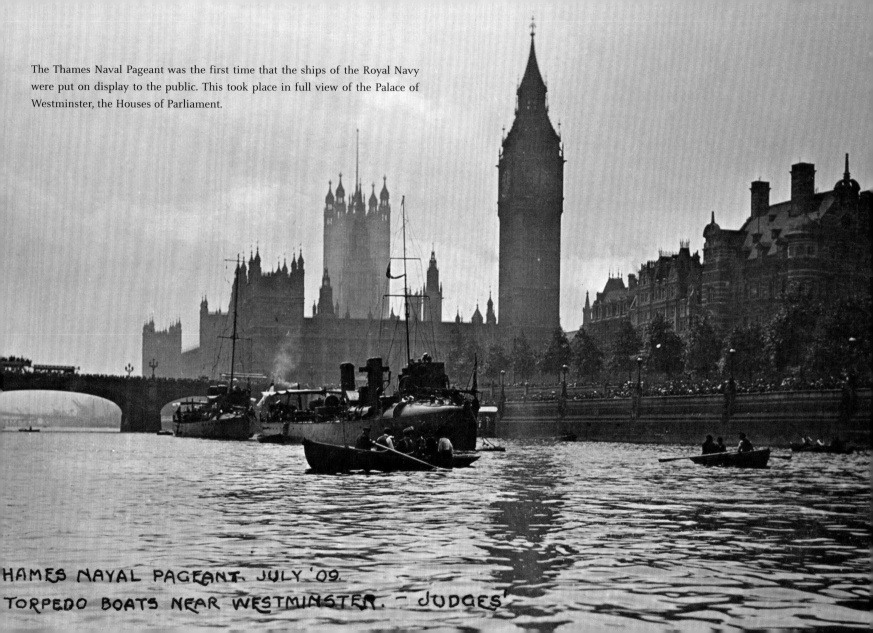

The Thames Naval Pageant was the first time that the ships of the Royal Navy were put on display to the public. This took place in full view of the Palace of Westminster, the Houses of Parliament.

HAMES NAVAL PAGEANT. JULY '09.
TORPEDO BOATS NEAR WESTMINSTER. — JUDGES'

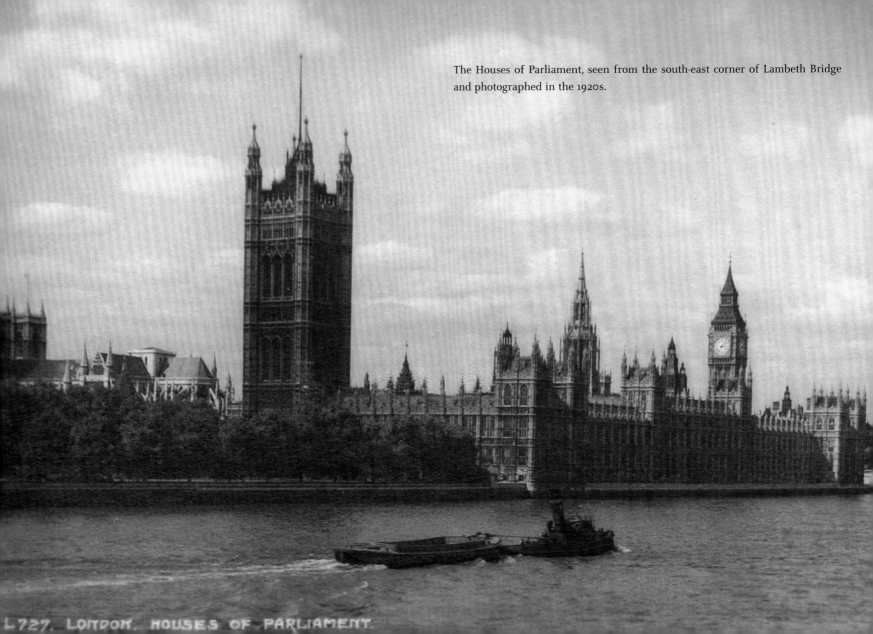

The Houses of Parliament, seen from the south-east corner of Lambeth Bridge and photographed in the 1920s.

L.727. LONDON. HOUSES OF PARLIAMENT.

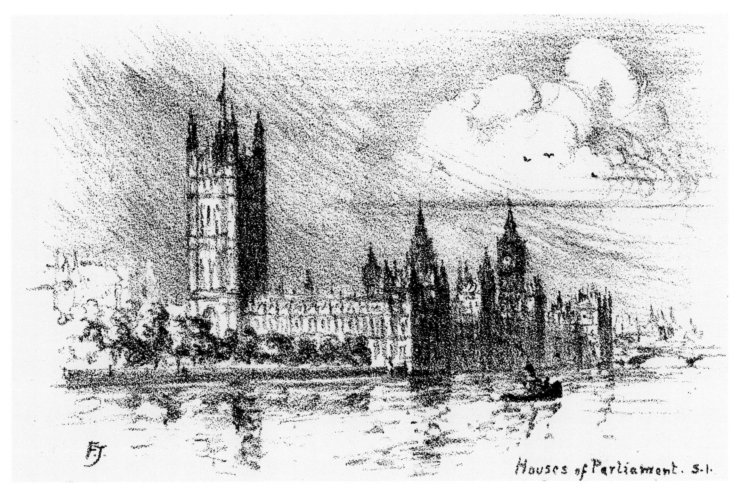

Houses of Parliament. S.1.

Fred Judge, a talented artist as well as a photographer, also drew pencil sketches of London scenes. It is very likely that this pencil sketch drawn in 1910 was his first of a London scene that was produced as a popular postcard.

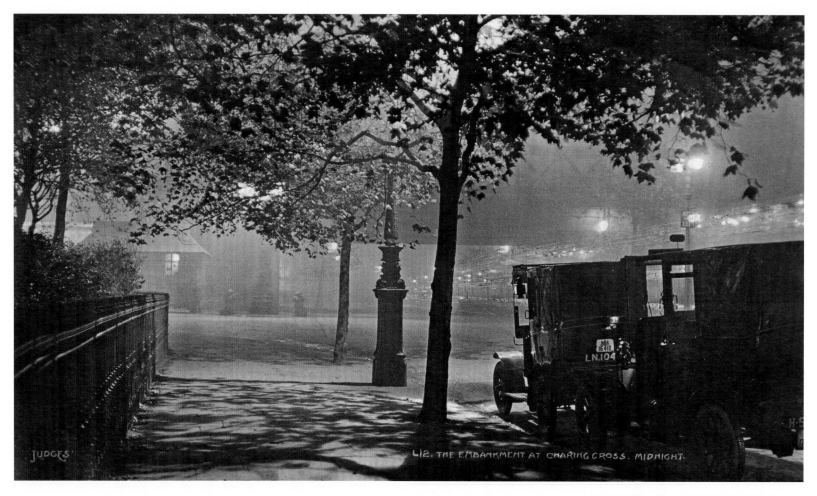

JUDGES'

L12. THE EMBANKMENT AT CHARING CROSS. MIDNIGHT.

Two London taxi cabs close to Charing Cross railway station on a misty night, *c*. 1910. The hut in the distance is a cabman's shelter. Many still exist and although, until recently, only taxi drivers were allowed entry, Prince Charles once popped into one for a cuppa and a chat.

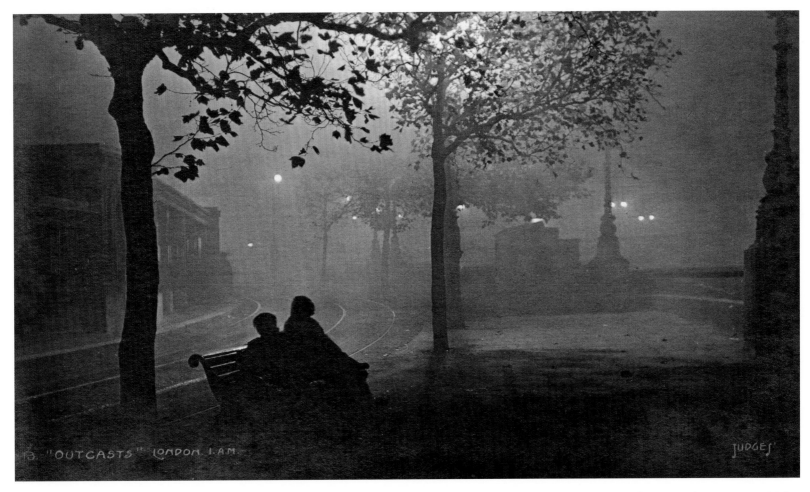

Two lonely, possibly homeless, men sitting on a bench close to the river on a gloomy night. This photograph was taken *c.* 1912. Electric tramlines are seen shining on the road.

Before the First World War coffee stalls were a prominent feature of London life, especially at night. When war broke out in 1914, and stallholders were conscripted into the army, some were allowed to set up their stalls behind the Front. Postcard, *c.* 1912.

LONDON. A COFFEE STALL AT 2 A.M.

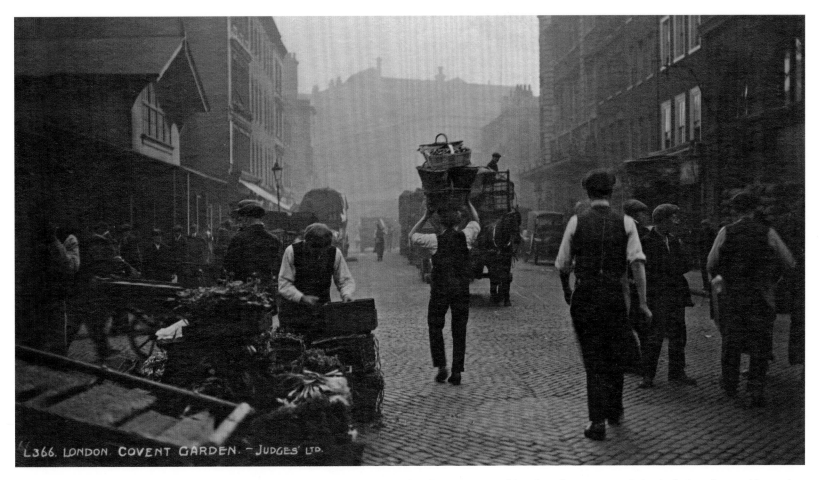

L366. LONDON. COVENT GARDEN. – JUDGES' LTD.

Covent Garden was a fruit and vegetable garden that once belonged to the monks of Westminster Abbey, later becoming a wholesale fruit and vegetable market. The market moved in the 1970s to make way for a busy tourist attraction. Today antiques and souvenirs are sold here with street performers entertaining the visitors.

L365. LONDON. IN COVENT GARDEN. – JUDGES' LTD.

The flower market once occupied the east side of Covent Garden near where the London Transport Museum and Royal Opera House stand today. Here customers view flowers that are to be used to decorate hotels, restaurants, London theatres and music halls.

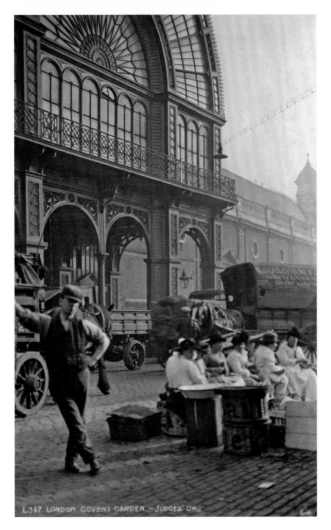

A market trader poses for the camera, while others take a break in Covent Garden fruit and vegetable market.

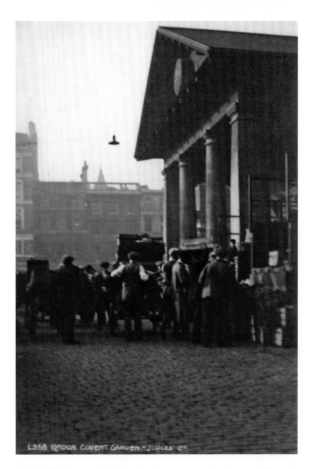

St Paul's Covent Garden, is known as the Actors' Church and has been associated with the theatre since the first performance of Punch & Judy on the cobbled street in 1662. Many memorials to great actors and actresses such as Sir Charlie Chaplin, Vivien Leigh and Boris Karloff can be seen inside the church.

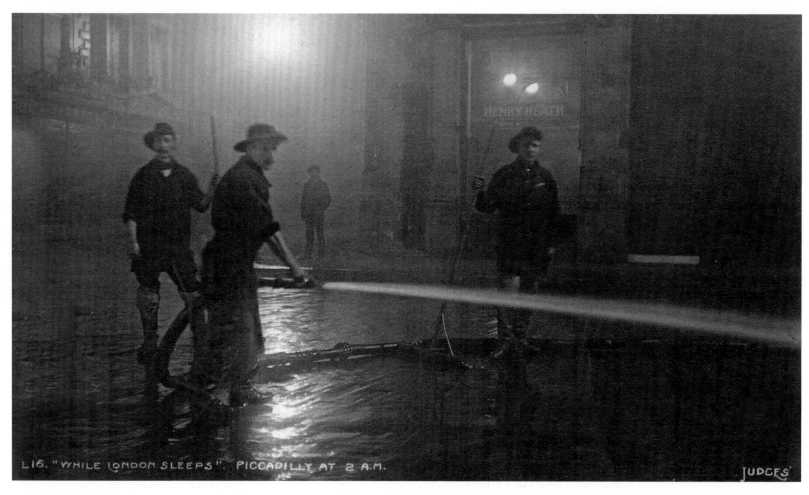

L16. "WHILE LONDON SLEEPS". PICCADILLY AT 2 A.M. JUDGES'

In the early twentieth century London was drowning in horse manure and urine from the thousands of horses entering London each day. Street cleaners are seen hosing the streets of Westminster at 2.00 a.m. The window of Henry Heath Ltd, the famous Edwardian top hat manufacturer, can be clearly seen.

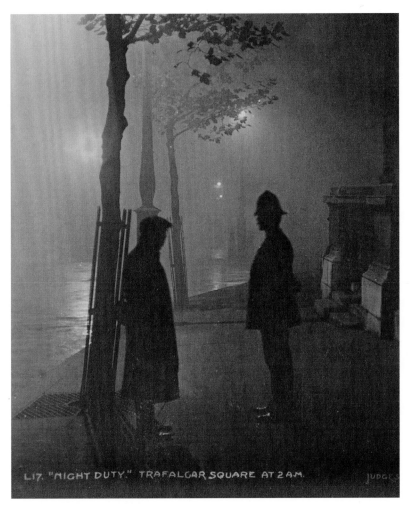

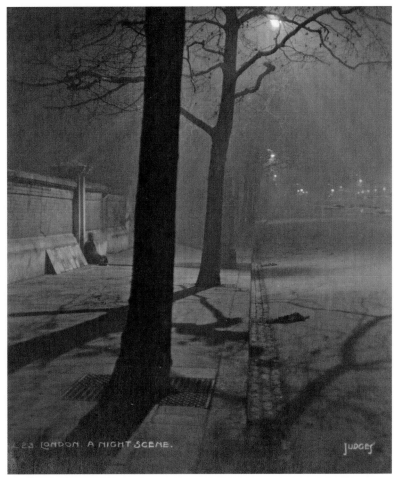

Trafalgar Square at night. A police officer questions a vagrant at 2.00 a.m., *c.* 1912.

An artist sitting on the pavement displaying his work on the Embankment at night, *c.* 1910.

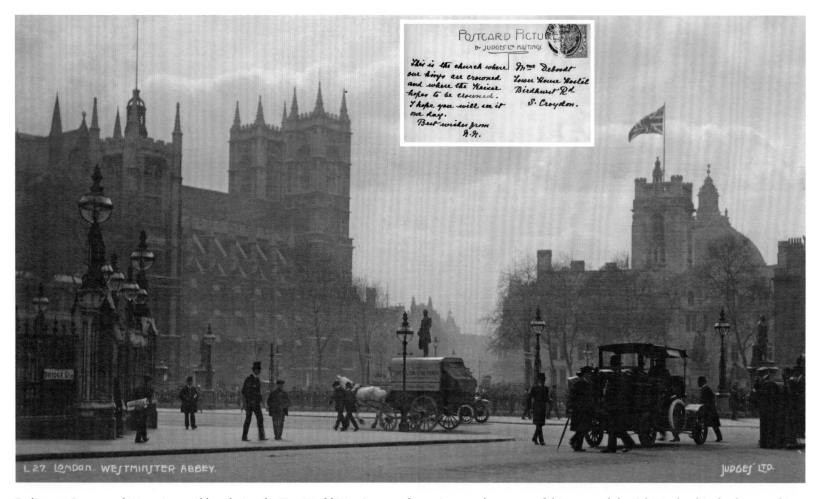

Parliament Square and Westminster Abbey during the First World War. Someone has written on the reverse of this postcard that 'This is the church where our kings are crowned and where the Kaiser hopes to be crowned.'

The old Lambeth Bridge, built on the site of the old horse ferry, *c.* 1912.

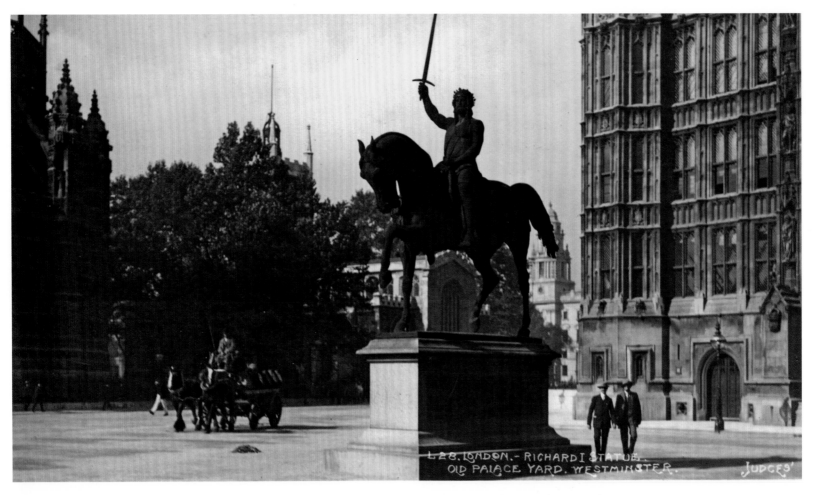

Statue of Richard Coer de Lion, Richard I, in Old Palace Yard opposite Westminster Abbey. Created by the Italian sculptor Baron Marochetti, this statue was first displayed at the Great Exhibition of London in 1851.

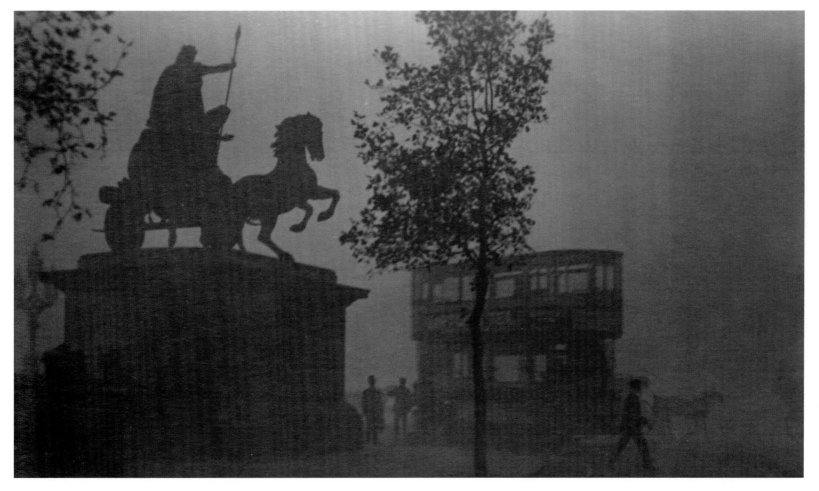

A London fog or 'pea-souper', *c.* 1911. Photograph taken from the north-east corner of Westminster Bridge and close to the Houses of Parliament; the statue of Boudicca, Queen of the Iceni, on her war chariot can be clearly seen. The tram is carefully turning onto the bridge with a horse-drawn cart beyond.

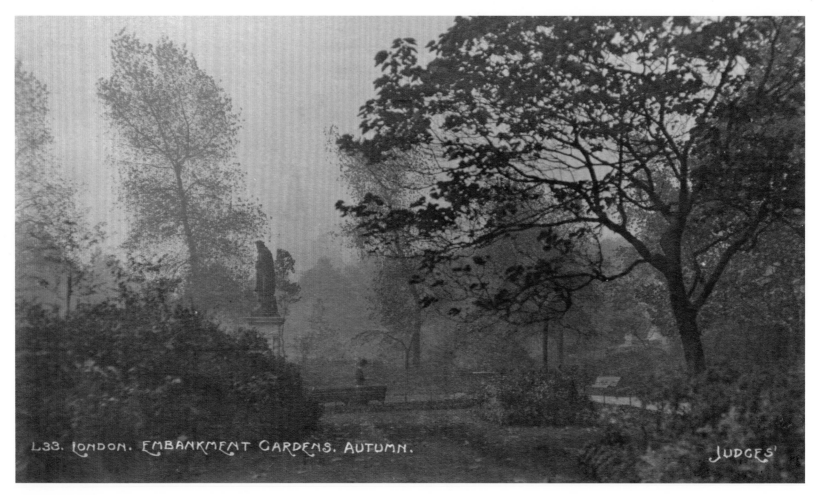

L33. LONDON. EMBANKMENT GARDENS. AUTUMN. JUDGES'

Statue of William Tyndale, 1494–1536, an English scholar who translated the Bible into English in the sixteenth century, can be seen in Embankment Gardens near Charing Cross. Between 1865 and 1870 the Embankment was constructed by reclaiming land from the river. The gardens were laid out in 1874.

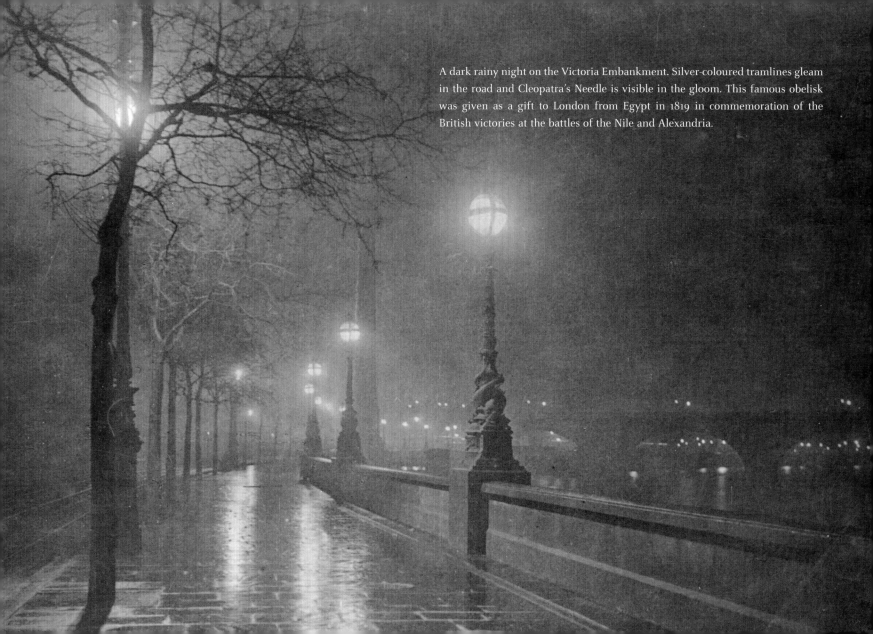

A dark rainy night on the Victoria Embankment. Silver-coloured tramlines gleam in the road and Cleopatra's Needle is visible in the gloom. This famous obelisk was given as a gift to London from Egypt in 1819 in commemoration of the British victories at the battles of the Nile and Alexandria.

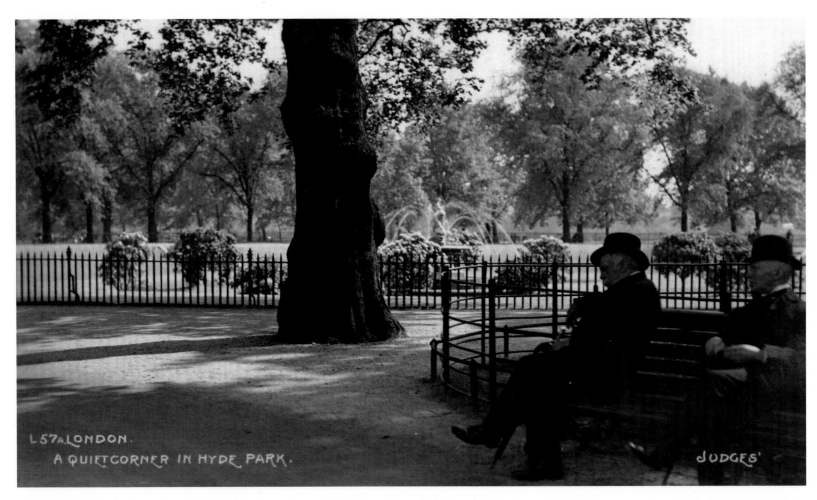

L 57a LONDON.
A QUIET CORNER IN HYDE PARK.

JUDGES'

Two gentlemen relax in a quiet corner of Hyde Park, *c.* 1920s. The park was laid out by Henry VIII in 1536. It was intended as an enclosed deer park to be used for the King's recreation. At the beginning of the seventeenth century, James I permitted limited public access to 'gentlefolk'.

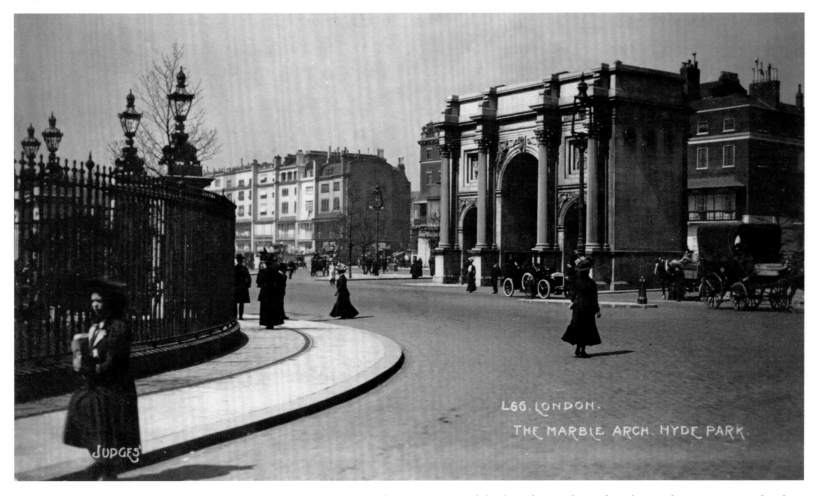

Marble Arch (*c.* 1909) at the western end of Oxford Street, Europe's longest shopping street. Built by the architect John Nash as the grand entrance into Buckingham Palace, it was moved to its present location to be the ceremonial gateway into Hyde Park. Today it is sadly isolated on a traffic island.

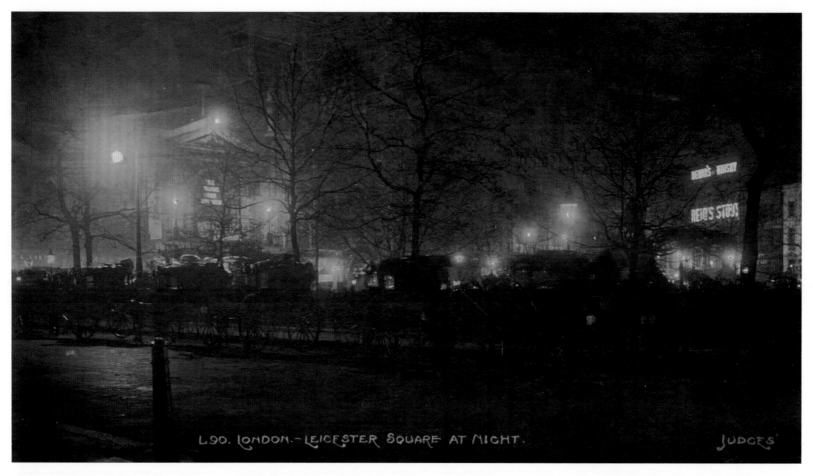

L90. LONDON.-LEICESTER SQUARE AT NIGHT. JUDGES'

Hansom cabs in Leicester Square, the heart of London's theatre district, *c.* 1913. Then, the music halls were very popular and there was no other way to travel than in style, by horse-drawn carriage or growler. Here they are awaiting theatre-goers and revellers to take them home. Today Leicester Square is more famous for its cinemas and film premieres.

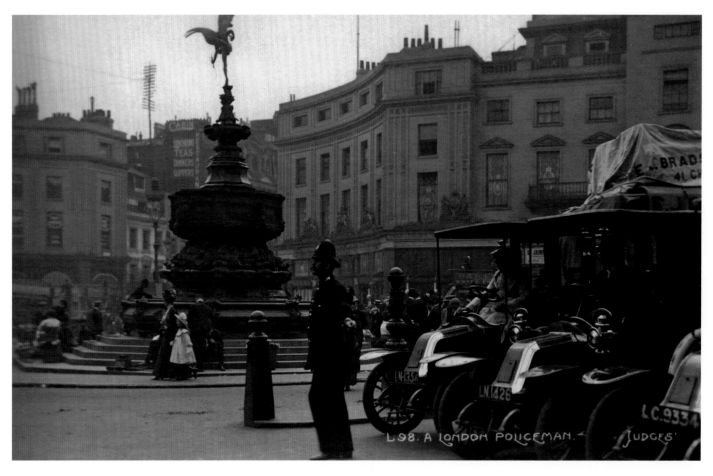

A policeman on traffic duty in Piccadilly Circus. The taxicabs he is holding back were made in France by Renault, and more than 500 worked the streets of London, picking up passengers from 1907 onwards. The French used these fine vehicles to transport troops to the Battle of the Marne (1914) during the First World War.

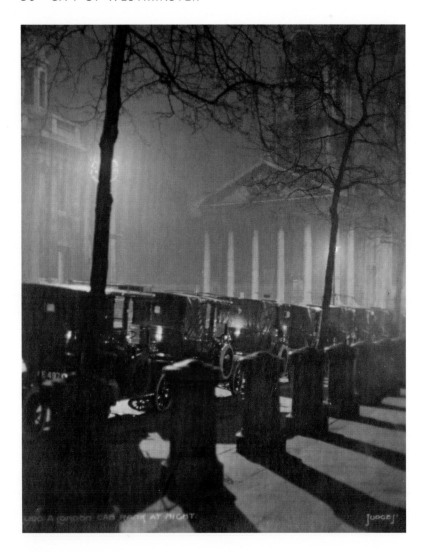

Left: A taxi rank at night by Trafalgar Square. In the background the Church of St Martin-in-the-Field is visible.

Opposite: The National Gallery in Trafalgar Square first opened its doors to the public in 1824 and is home to the European collection of art from the thirteenth century to the beginning of the 1900s. To its right is the Church of St Martin-in-the-Fields, famed for hosting classical concerts.

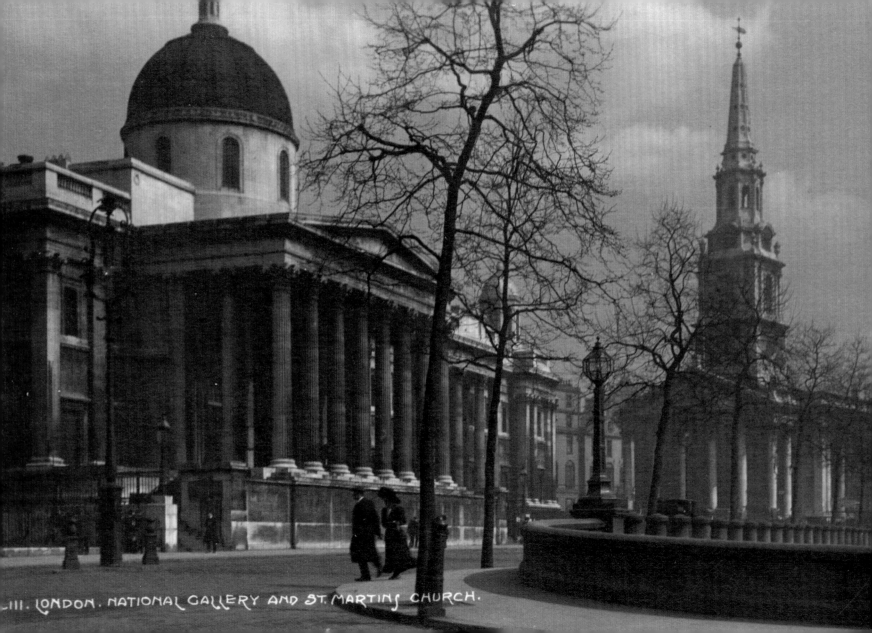

LONDON. NATIONAL GALLERY AND ST. MARTINS CHURCH.

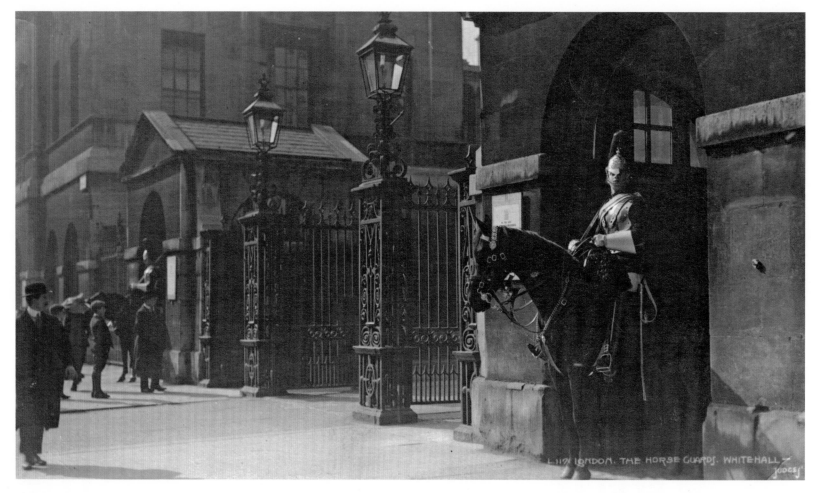

The entrance to the Horse Guards building in Whitehall. This is the headquarters of the Household Cavalry division of the British Army whose duty it is to protect the Royal Family at ceremonial events. This is a popular attraction, with the soldiers on duty between 10.00 a.m. and 4.00 p.m. each day.

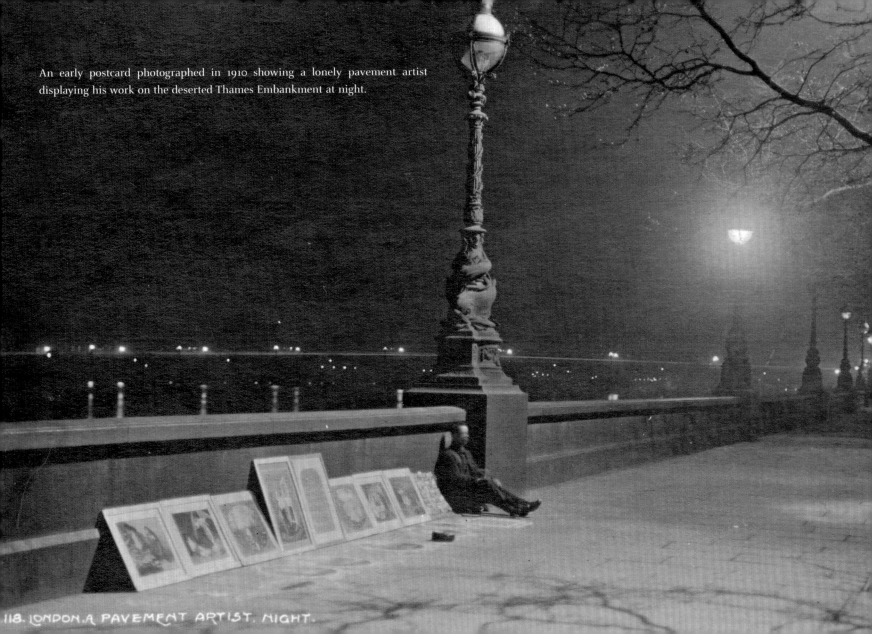

An early postcard photographed in 1910 showing a lonely pavement artist displaying his work on the deserted Thames Embankment at night.

118. LONDON. A PAVEMENT ARTIST. NIGHT.

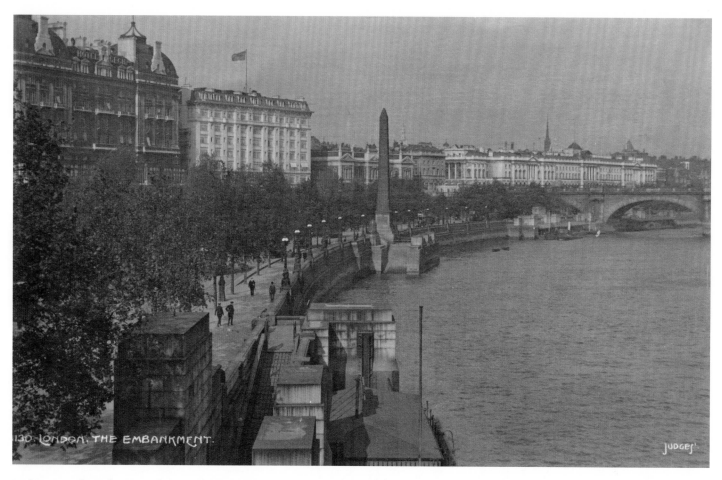

130 LONDON. THE EMBANKMENT.

JUDGES'

Looking east along the River Thames. The building to the left is the Cecil Hotel, one of London's grandest hotels that was requisitioned to become the headquarters of the new Royal Air Force during the First World War. To its right stands the lavish Savoy Hotel, the first hotel in the country to introduce electric lighting, electric elevators and running hot water.

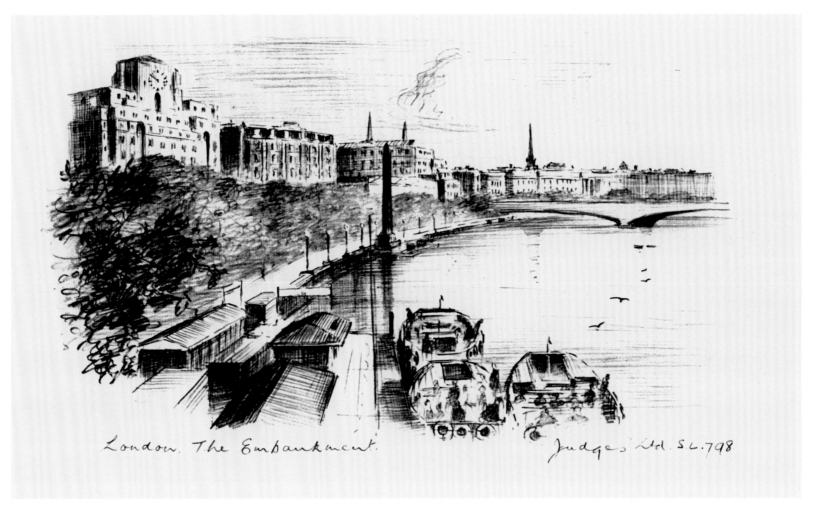

This pencil sketch of the same scene was reissued as a postcard in the 1950s.

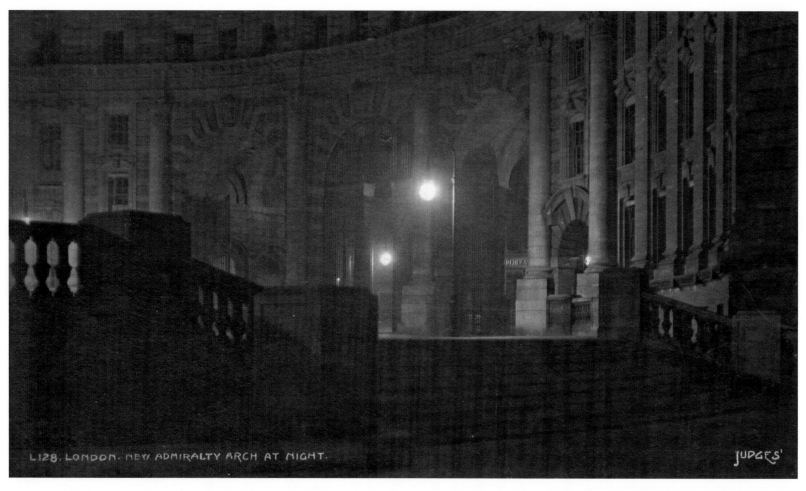

L128. LONDON. NEW ADMIRALTY ARCH AT NIGHT. JUDGES'

The new Admiralty Arch at night. Completed in 1912 and designed by the architect Sir Aston Webb, it proudly stands next to the Old Admiralty building and is the entrance to The Mall that leads to Buckingham Palace.

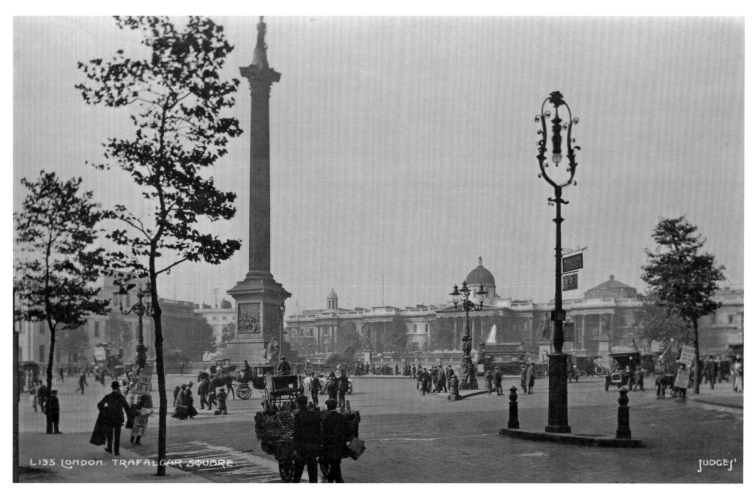

L135 LONDON. TRAFALGAR SQUARE JUDGES'

A busy scene of a horse-drawn taxicab, motorised vehicles and market traders can be seen in this Edwardian photograph of Trafalgar Square. Beyond Nelson's Column stands the National Gallery. The building on the left-hand side of the Square became the Canadian High Commission in the 1920s.

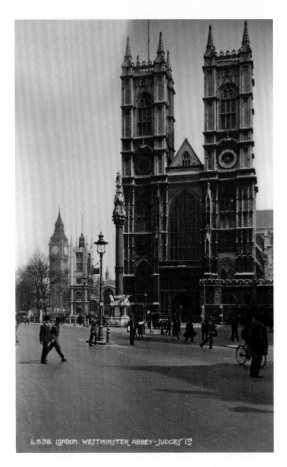

Westminster Abbey seen from Victoria Street. In the distance is the Elizabeth Clock Tower housing Big Ben, the bell that strikes each hour. The column in front of the abbey is a memorial to the pupils of Westminster School who fell in the Crimean War of 1853–56.

Westminster Abbey was rebuilt between the thirteenth and sixteenth centuries. However, the western towers were not added until the 1740s. The architect Christopher Wren was responsible for its designs and his protégé, Nicholas Hawksmoor, for its construction.

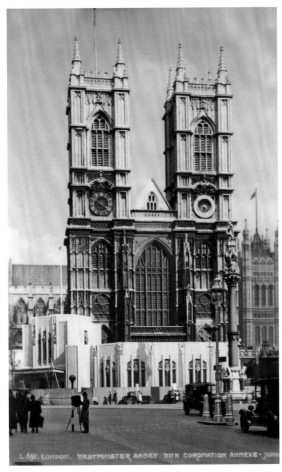

A temporary annexe was built at the western end of the abbey for the coronation of George VI in 1937. This white building housed the robing and retiring rooms of the new monarch, a stark contrast to the grimy building that has now been thoroughly cleaned.

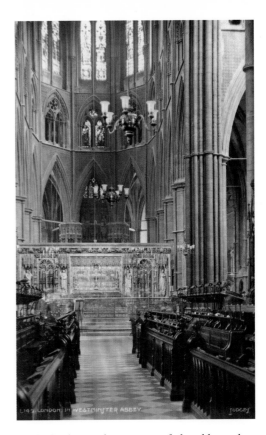

The high altar and sanctuary of the abbey where coronations are held. Here the funeral service of Princess Diana took place in 1997, as well as the wedding of Prince William to Kate Middleton in 2011. Built in the Gothic style, this is the second abbey on this site; the first, in the Romanesque style, was built by Edward the Confessor who is enshrined beyond the screen.

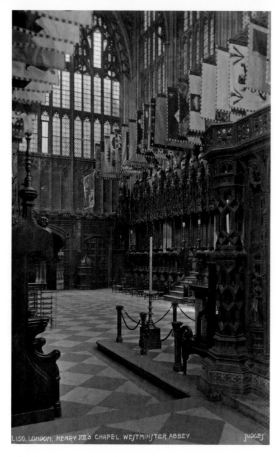

LISO. LONDON, HENRY VII'S CHAPEL, WESTMINSTER ABBEY. JUDGES

The Henry VII Chapel of Westminster Abbey was built with money left in the king's will. This magnificent chapel, built between 1503 and 1509 and in the later Perpendicular Gothic style, is also the Chapel of the Most Honourable Order of the Bath, the fourth most important order of chivalry.

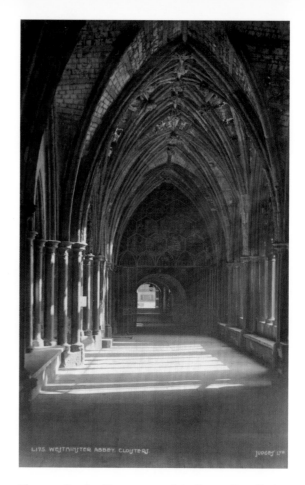

L175. WESTMINSTER ABBEY, CLOISTERS. JUDGES LTD

The medieval abbey was originally a Benedictine monastery before the Reformation in the 1530s. Cloisters were used by the monks for recreational purposes. The windows were glazed with stained glass depicting scenes from the Bible and images of the saints.

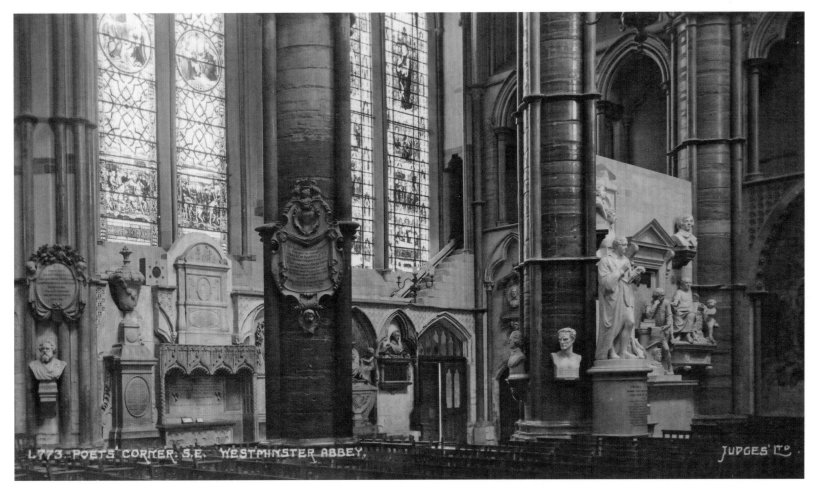

L773 POETS CORNER. S.E. WESTMINSTER ABBEY. JUDGES LTO

Geoffrey Chaucer, author of *The Canterbury Tales,* was the first person to be interred in Poets' Corner. Among those buried or commemorated here are William Shakespeare, Lewis Carroll, Lord Byron, Dame Edith Evans, Sir Laurence Olivier and Charles Dickens.

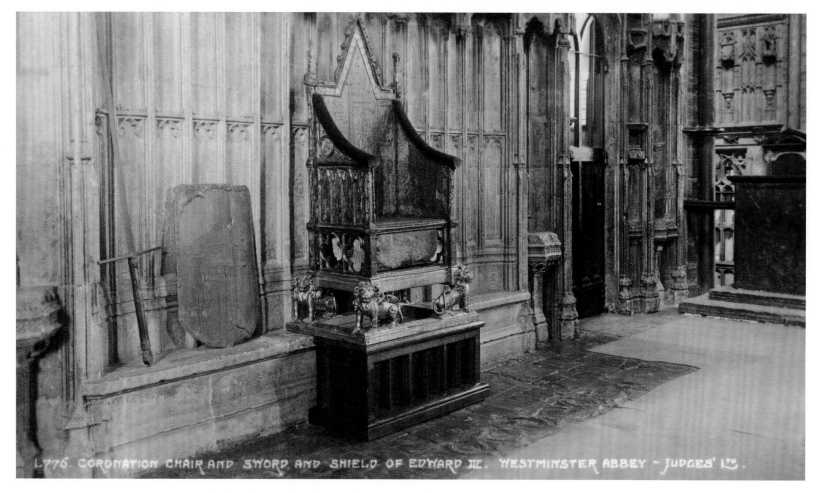

L776. CORONATION CHAIR AND SWORD AND SHIELD OF EDWARD III. WESTMINSTER ABBEY - JUDGES' LTD.

The Coronation Chair in Westminster Abbey was built during the reign of Edward I for the coronation of his son Edward II in 1308, and has been used for every coronation since. Edward III's shield and two-handed sword can be seen in the abbey museum. The sword is 7 feet long and weighs 18lbs.

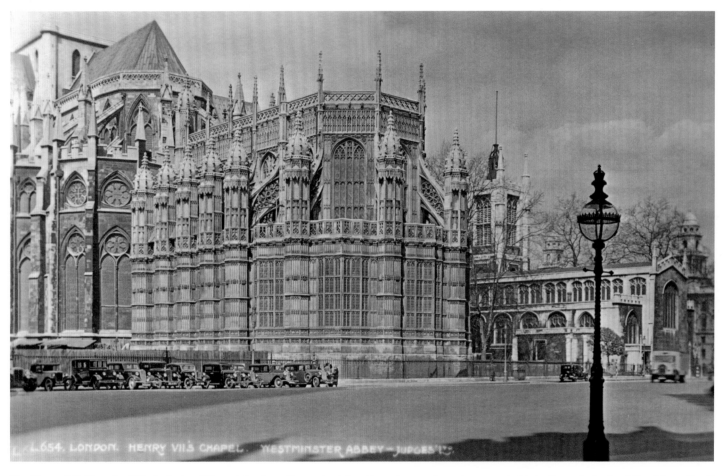

L.654. LONDON. HENRY VII'S CHAPEL. WESTMINSTER ABBEY – JUDGES' LTD

The Henry VII Chapel of Westminster Abbey dates from the early sixteenth century and was incorporated into the main body of the abbey after it was finally completed. This later style of architecture is called Perpendicular Gothic. The abbey is officially called The Collegiate Church of St Peter at Westminster. Note the row of fine cars in an almost deserted street.

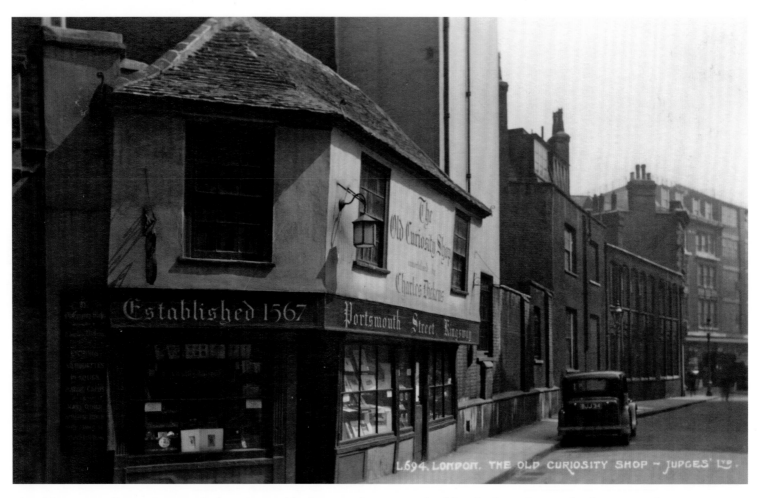

The Old Curiosity Shop in Portsmouth Street is possibly the same shop immortalised by Charles Dickens in his famous novel.

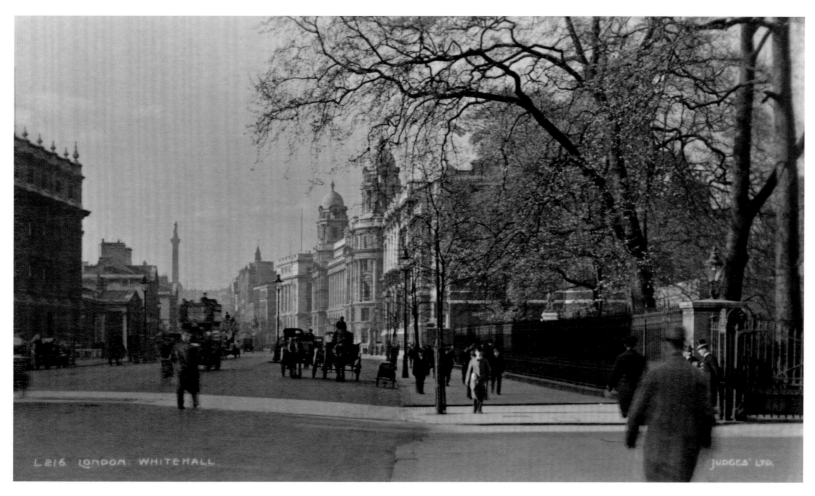

Whitehall, a wide thoroughfare leading from Parliament Street to Trafalgar Square, is home to government buildings and where Whitehall Palace once stood. Here Charles I was beheaded in 1649. In the distance Nelson's Column stands proud marking Trafalgar Square.

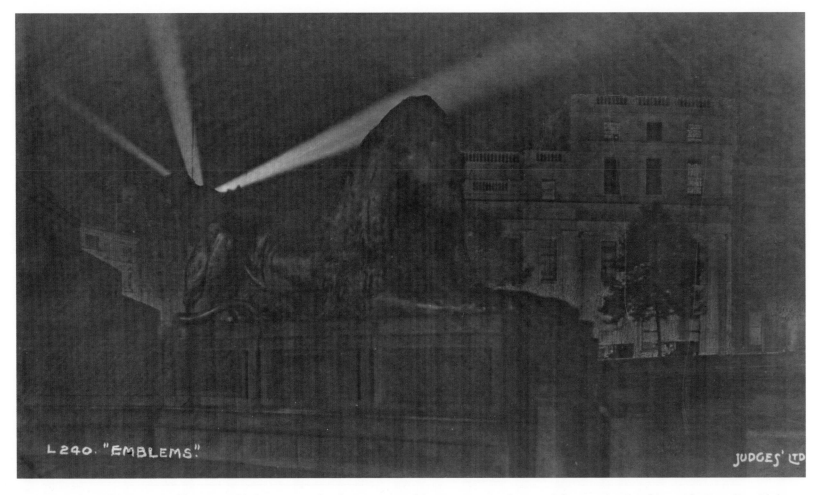

L240. "EMBLEMS"

JUDGES' LTD

At the beginning of the First World War searchlights were used to form anti-aircraft barriers over London as a defence against bombing raids. Zeppelin raids began in 1915 but by 1917 they were replaced by aeroplanes as these were more accurate when dropping bombs. This photograph was taken from Trafalgar Square *c.* 1915.

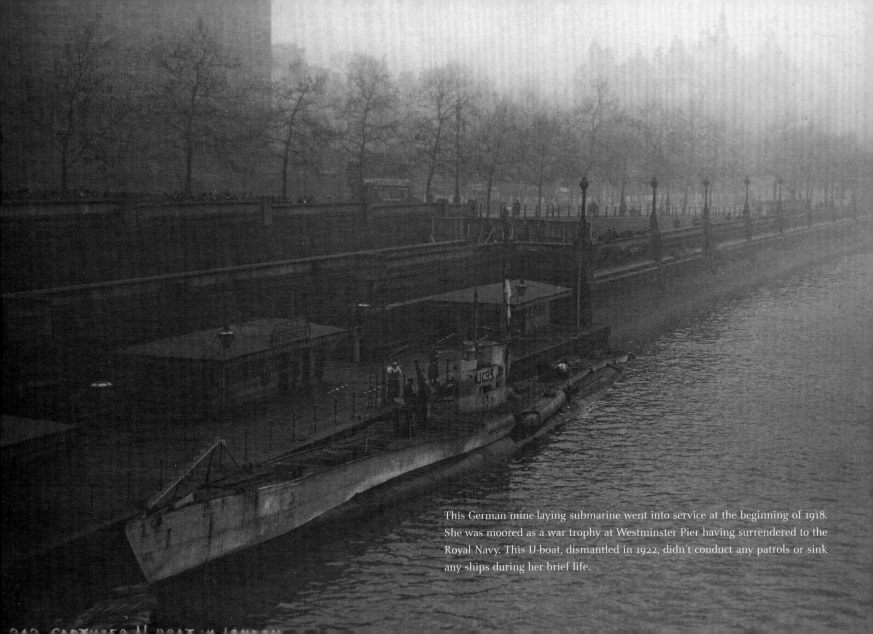

This German mine-laying submarine went into service at the beginning of 1918. She was moored as a war trophy at Westminster Pier having surrendered to the Royal Navy. This U-boat, dismantled in 1922, didn't conduct any patrols or sink any ships during her brief life.

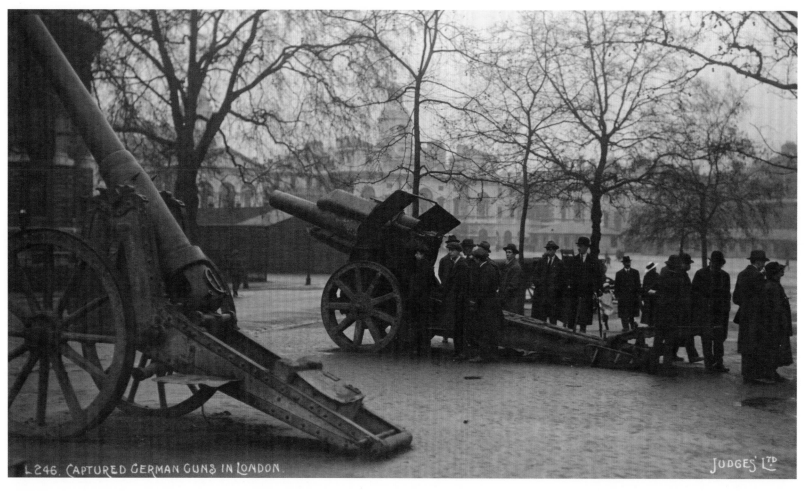

L246. CAPTURED GERMAN GUNS IN LONDON. JUDGES LTD

After the armistice of the First World War, many captured German guns were publicly displayed around London. This photograph was taken from St James's Park looking towards Horse Guards Parade.

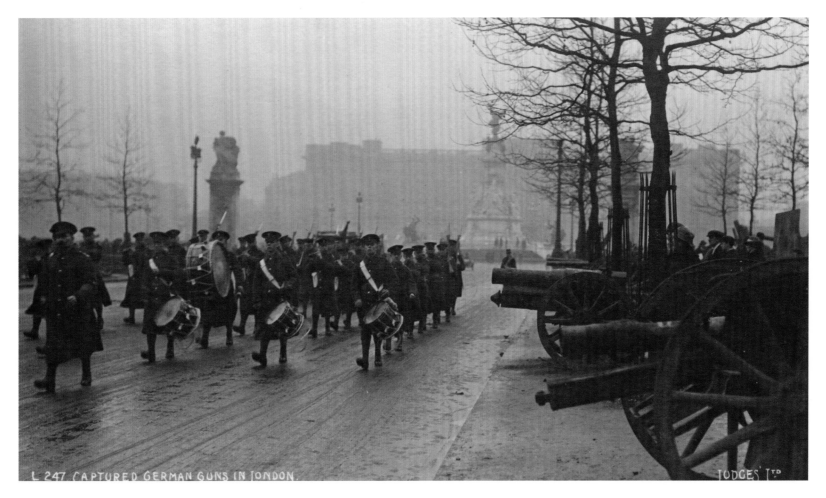

His Majesty's Foot Guards on their way to St James's Palace from Buckingham Palace, wearing their greatcoats and forage caps. They march past enemy guns captured from the battlefields of Europe during the First World War. Photographed in The Mall at the beginning of 1919.

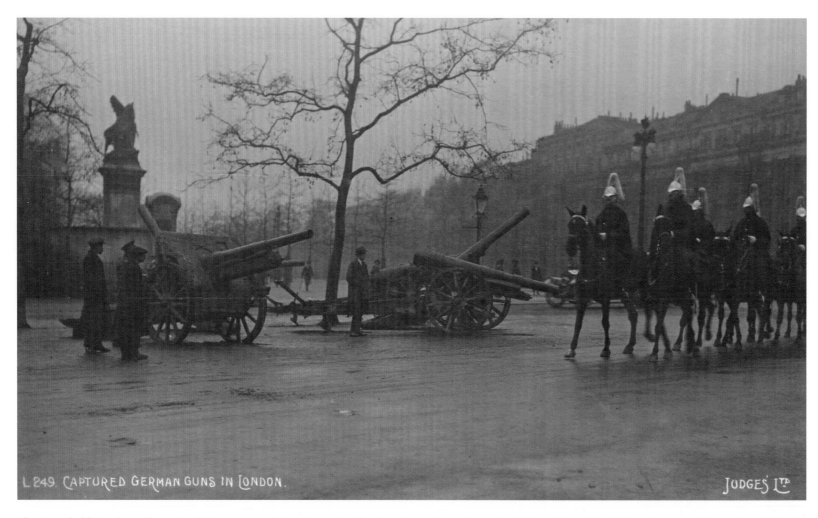

L 249. CAPTURED GERMAN GUNS IN LONDON.

JUDGES LTD

The Household Cavalry, with captured German guns lining the route. They have turned into Horse Guards Road from The Mall on the way to Horse Guards Parade.

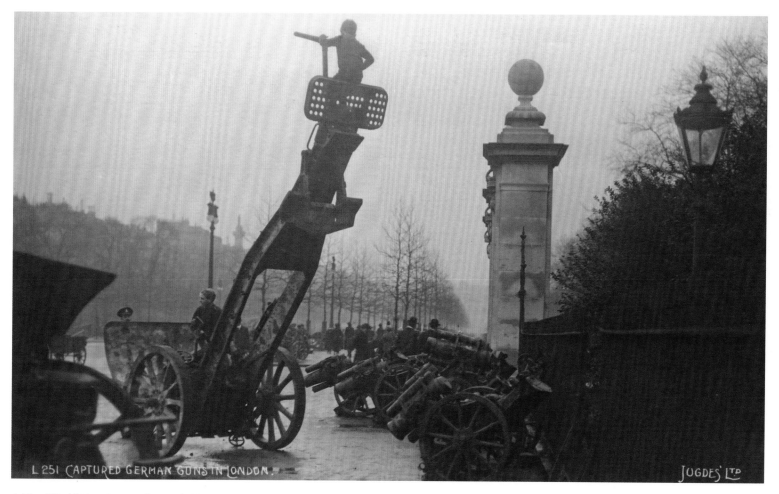

A First World War German heavy field howitzer. The barrel is pointing downwards as a war trophy. A young boy has climbed to the top to get a good view of the surroundings.

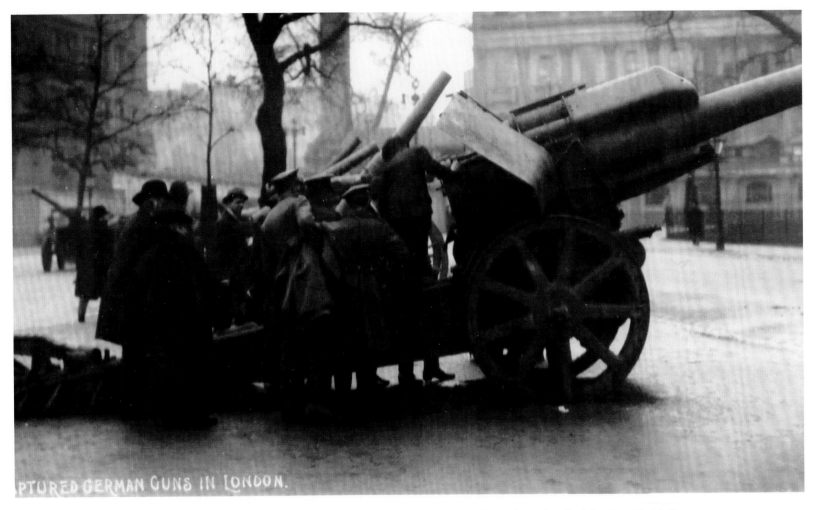

PTURED GERMAN GUNS IN LONDON.

Crowds gather around a captured German long-range mortar. This outstanding weapon was used from the outbreak of the First World War.

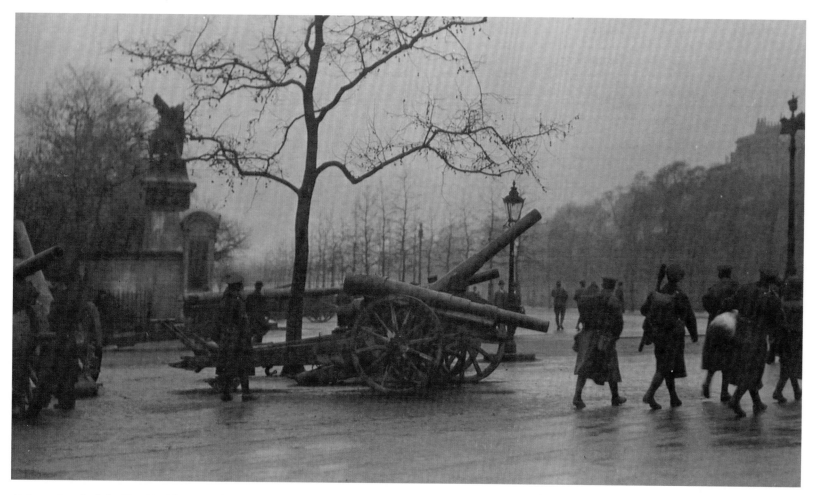

At the outbreak of the First World War Fred Judge, then forty-two years of age, secured a War Department permit that allowed him to continue taking photographs. This extended to 1919 when Fred came to London to take these outstanding photographs of captured German guns.

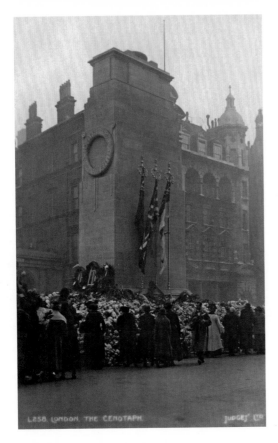

The First World War ended at 11.00 a.m. on the 11 November 1918. On the nearest Sunday to the 11 November each year at 11.00 a.m. thousands of people gather to remember the dead at the Cenotaph in Whitehall. The Royal family, religious leaders, politicians, world leaders, members of the armed forces and other dignitaries pay their respects to the fallen.

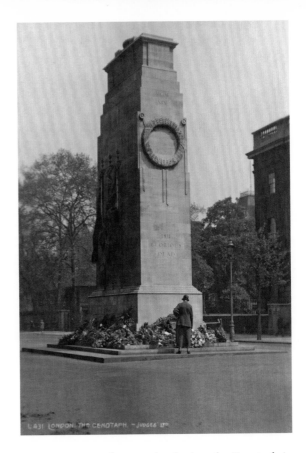

A woman pays tribute to the dead at the Cenotaph in Whitehall. 'Cenotaph' is a Greek word meaning 'empty tomb'. Designed by the British architect Sir Edwin Lutyens, and unveiled in 1920, remembrance services are held every year to commemorate the fallen of two world wars and later conflicts involving British and Commonwealth forces.

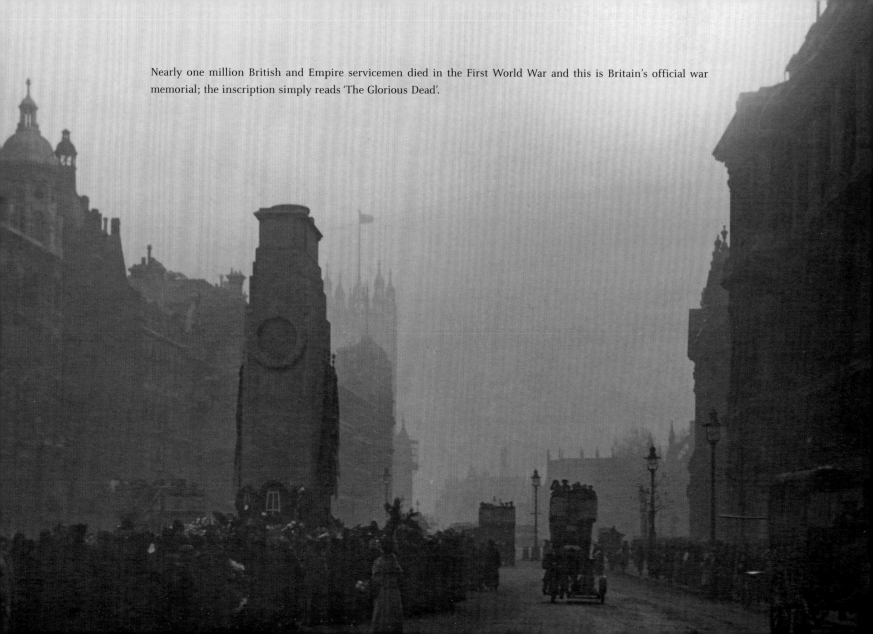

Nearly one million British and Empire servicemen died in the First World War and this is Britain's official war memorial; the inscription simply reads 'The Glorious Dead'.

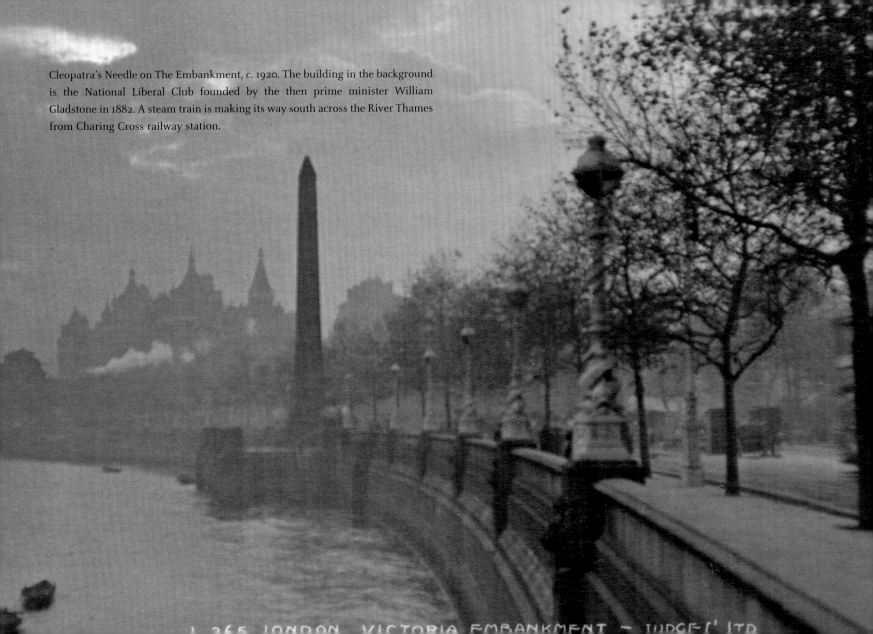

Cleopatra's Needle on The Embankment, *c.* 1920. The building in the background is the National Liberal Club founded by the then prime minister William Gladstone in 1882. A steam train is making its way south across the River Thames from Charing Cross railway station.

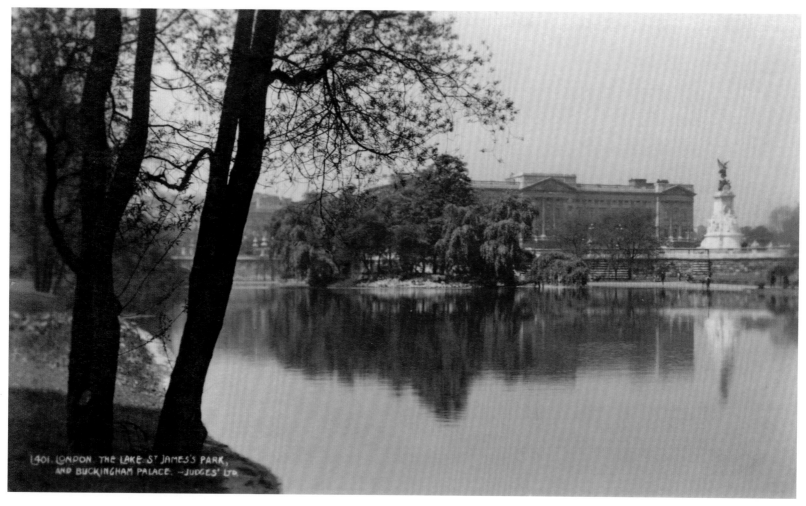

1401. LONDON. THE LAKE. ST JAMES'S PARK, AND BUCKINGHAM PALACE. —JUDGES' LTD

The lake in St James's Park. Buckingham Palace and the Queen Victoria Memorial are in the background.

The Household Cavalry on their way to their stables and barracks. The Horse Guards building in the background once served as the headquarters of the British Army. The parade ground was the tilt-yard of the long-demolished Whitehall Palace.

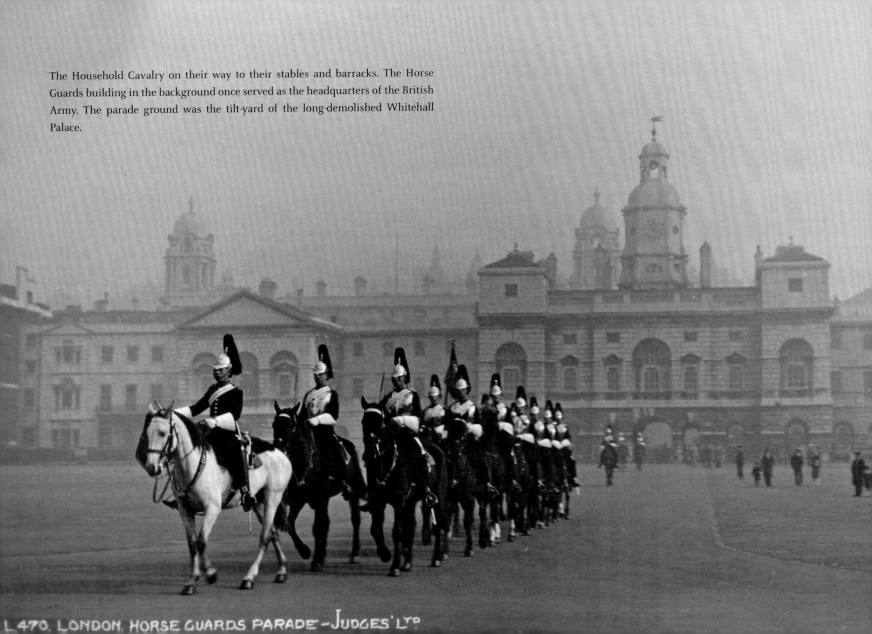

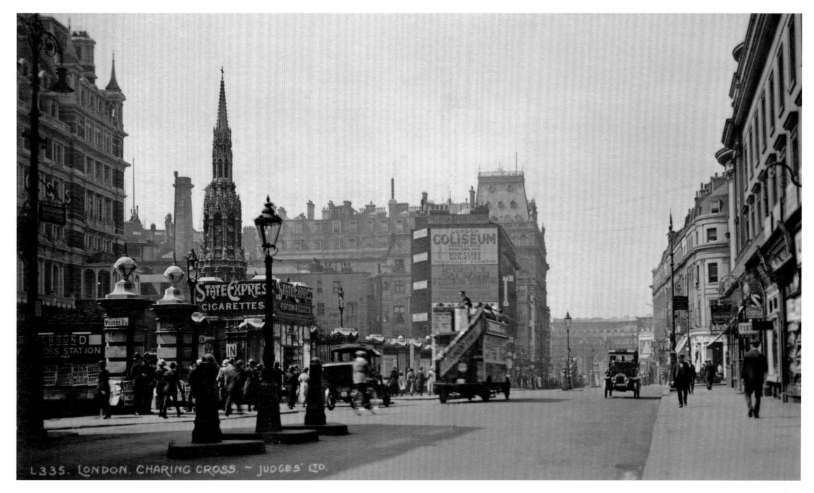

The Strand at Charing Cross, *c.* 1918. In the forecourt of Charing Cross railway station is the Victorian replica of the Eleanor Cross. The original was placed here in 1290 by Edward I to mark Queen Eleanor's resting place before continuing to Westminster Abbey for burial.

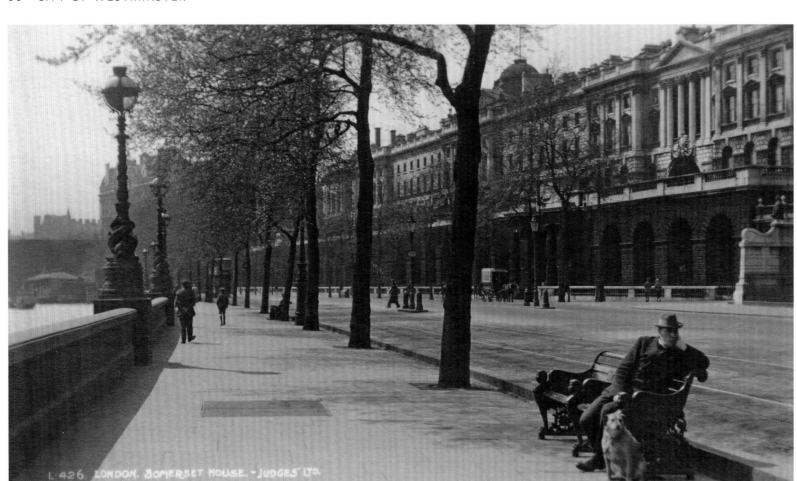

L 426. LONDON. SOMERSET HOUSE. - JUDGES' LTD.

A gentleman resting while taking his dog for a walk along The Embankment. Somerset House, in the background, was once the site of a sixteenth-century Tudor palace. Today it is a cultural and arts centre housing museums and art galleries.

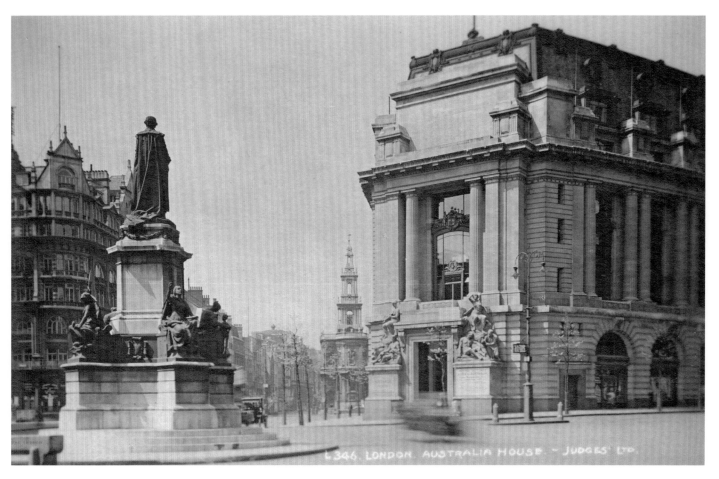

The statue of William Gladstone, nineteenth-century prime minister, looks towards the Australian High Commission and St Clement Dane Church, the church of the Royal Air Force. The High Commission was officially opened by George V in 1918. Much of the material used for its construction was shipped to London from Australia.

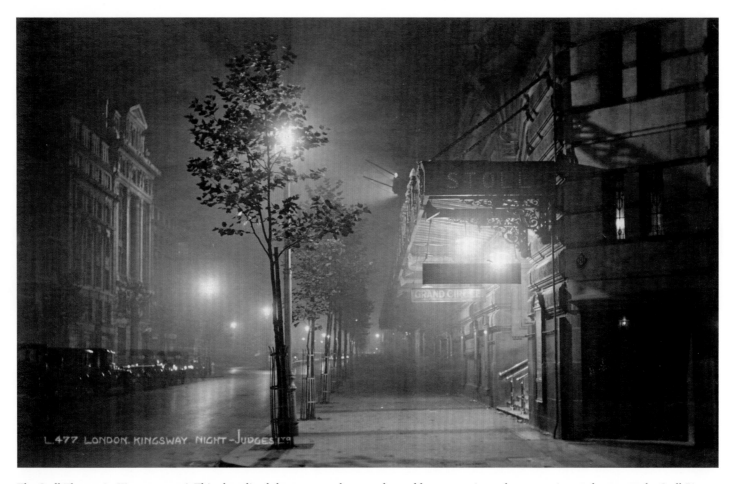

The Stoll Theatre in Kingsway, 1916. This short-lived theatre proved unpopular and became a picture house, or cinema, known as the Stoll Picture House. Close to its original location is the well-known Peacock Theatre owned by the London School of Economics where conferences, exhibitions, pop concerts and graduation ceremonies take place.

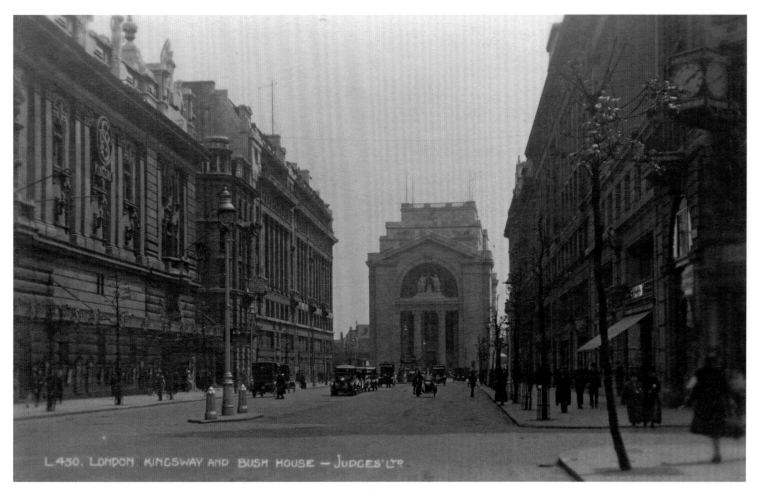

Looking south along Kingsway towards Bush House in Aldywch. Bush House was once the headquarters of the British Broadcasting Corporation's Overseas Service, broadcasting radio programmes all over the world.

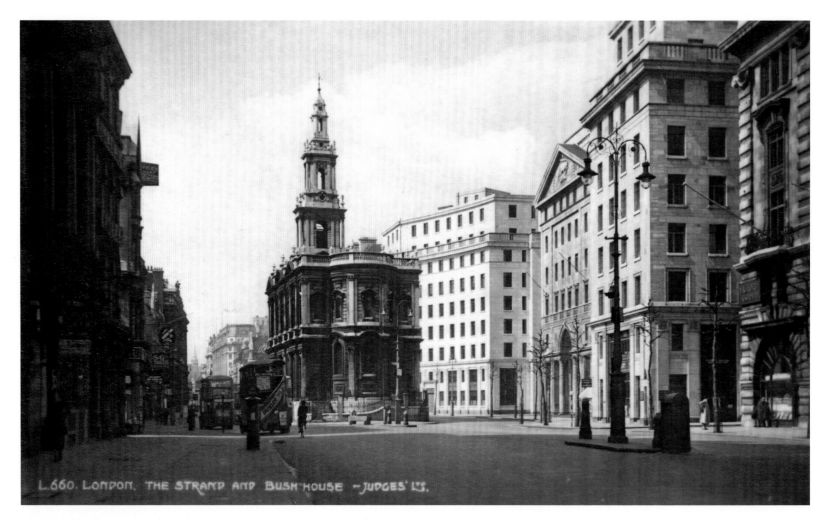

L.660. LONDON. THE STRAND AND BUSH HOUSE — JUDGES' L.ᵈ.

The Strand looking west with St Clement Danes Church in the centre of the road and Bush House to its left.

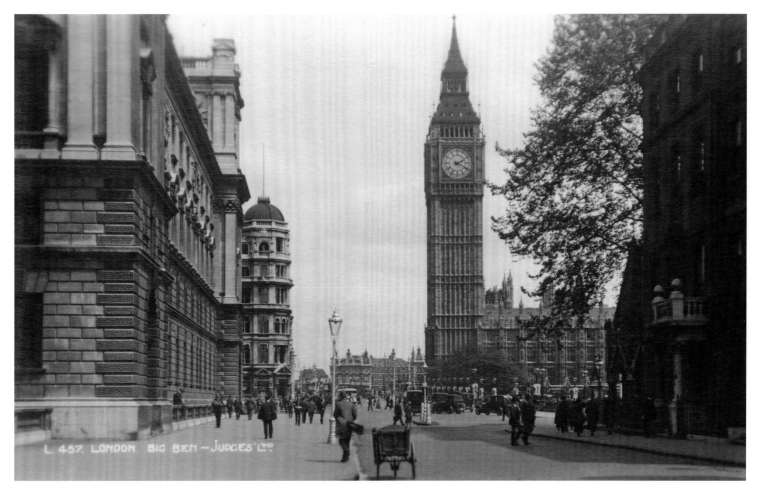

Looking towards Westminster Bridge and the River Thames. Big Ben dominates the scene. A lesser-known fact about this famous landmark is that no one can actually see Big Ben. Weighing nearly 14 tons it is the huge bell hidden away behind the clock face of the Elizabeth Tower.

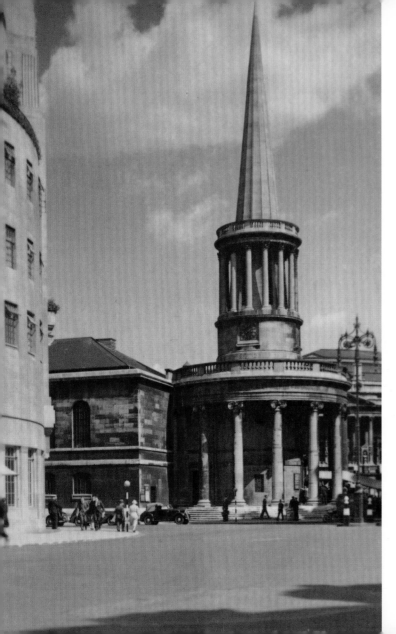

Left: All Souls Church (seen here *c.* 1940), Langham Place, was designed by the architect John Nash, also responsible for planning and designing large areas of Regency London. All Souls is the official church of the British Broadcasting Corporation and stands adjacent to its headquarters.

Opposite: The National Gallery holds a vast collection of some of the world's most famous paintings. The statue close to the railings is of George Washington. It was given as a gift in 1921 by the people of Richmond, Virginia. Washington stands on a stone plinth to remind us that he was supposed to have said that he never wished to stand on English soil.

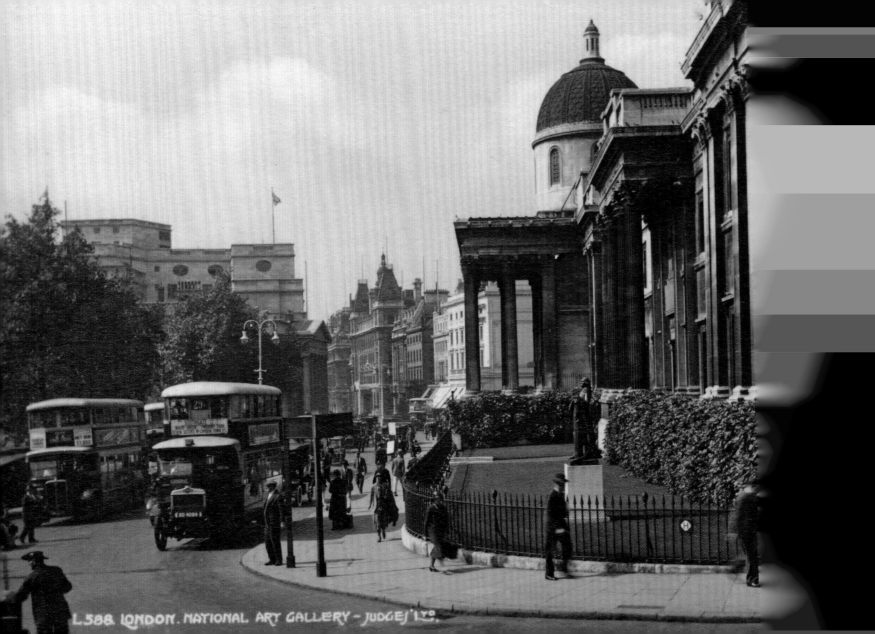

L.588 LONDON. NATIONAL ART GALLERY - JUDGES' LTD.

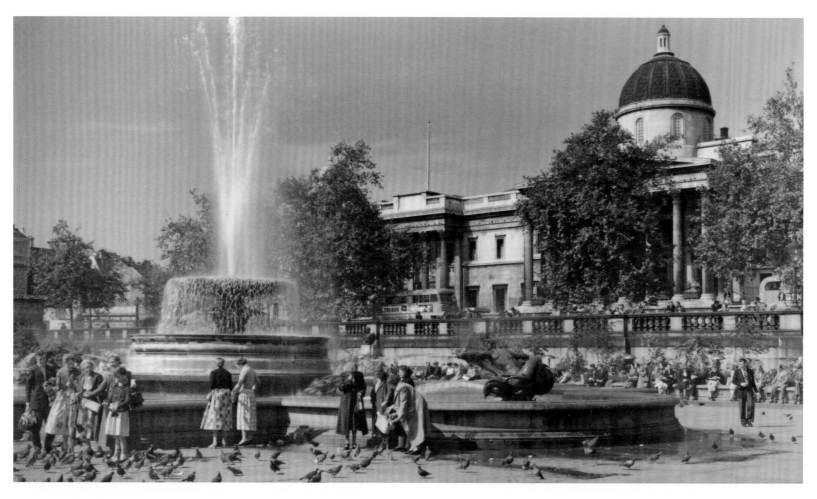

This unnumbered and untitled proof copy of Trafalgar Square and the National Gallery may never have been published as a postcard; however, an attractive sketch was drawn that was sold as a popular postcard, as seen opposite.

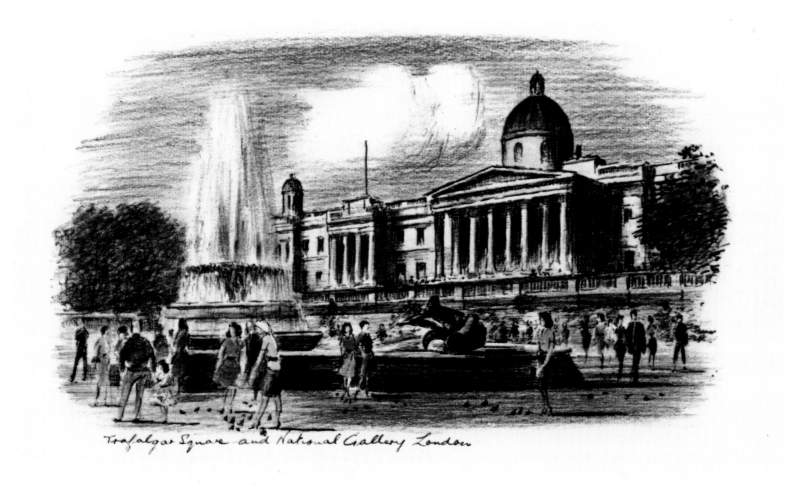

Trafalgar Square and National Gallery London

This pencil sketch was drawn by William H. Constantine, an artist employee of the company, after the death of Fred Judge, and was issued as a postcard in the 1960s.

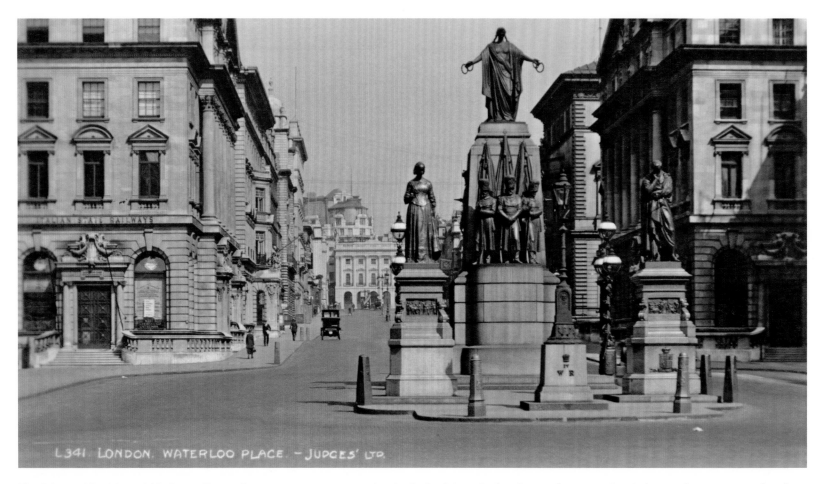

L341. LONDON. WATERLOO PLACE. – JUDGES' LTD.

The Crimean War Memorial in Lower Regent Street commemorates our victories in the Crimea in the nineteenth century. Cast in bronze from cannons taken from the battlefields, three guardsmen lower their heads in mourning for their dead comrades. To the left is the figure of Florence Nightingale, The Lady of the Lamp, who nursed sick soldiers on the battlefield. To the right is a statue of Sidney Herbert, Secretary of War. Overlooking all from above is the figure representing Honour.

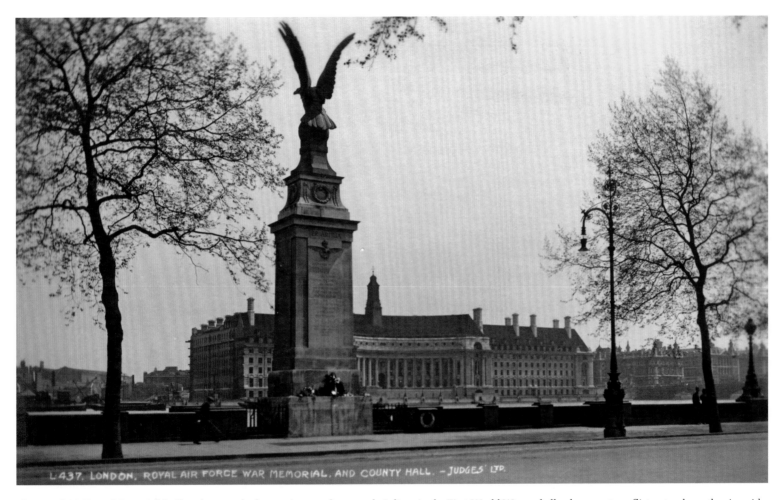

L 437. LONDON. ROYAL AIR FORCE WAR MEMORIAL, AND COUNTY HALL. – JUDGES' LTD.

The Royal Air Force Memorial, built to honour the brave airmen who gave their lives in the First World War and all subsequent conflicts, stands on the riverside. The eagle, the emblem of the RAF, faces France. Across the river is the monumental County Hall building, once headquarters of the Greater London Council.

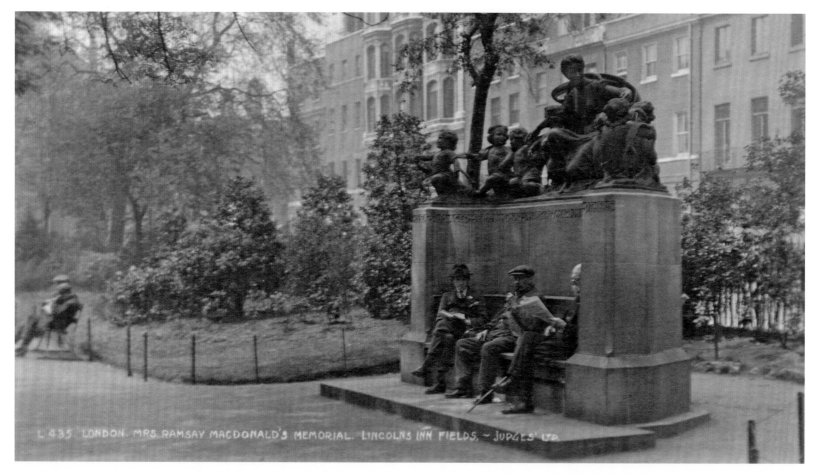

L 435 LONDON. MRS. RAMSAY MACDONALD'S MEMORIAL. LINCOLNS INN FIELDS, ~ JUDGES' LTD

Lincoln's Inn Fields is a garden square on the border of Westminster and neighbouring Camden where there is a memorial seat to honour Mrs Margaret MacDonald, wife of the first Labour prime minister Ramsay MacDonald who came to office in 1924. Relaxing are three men who are reading and smoking possibly posing for the photograph.

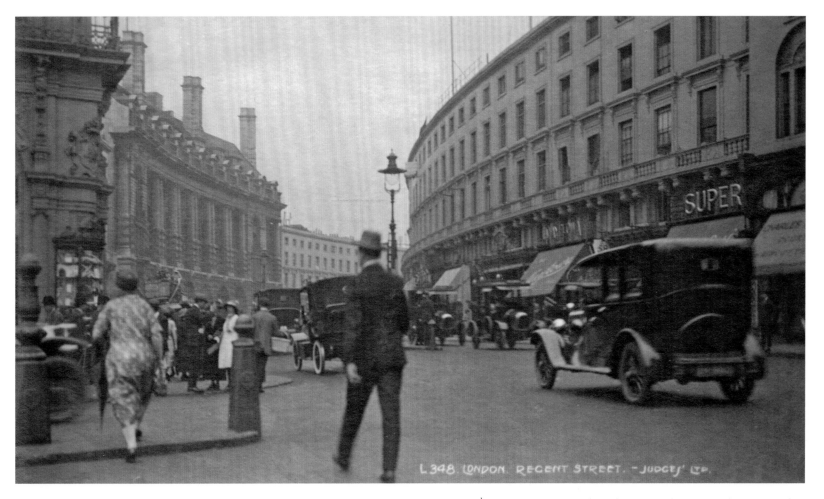

L 348. LONDON. REGENT STREET. - JUDGES' LTD.

Regent Street today is one of the busiest streets in London, even more so than in the 1930s and '40s. Here we see people rushing to work or going shopping in this, one of London's premier shopping streets.

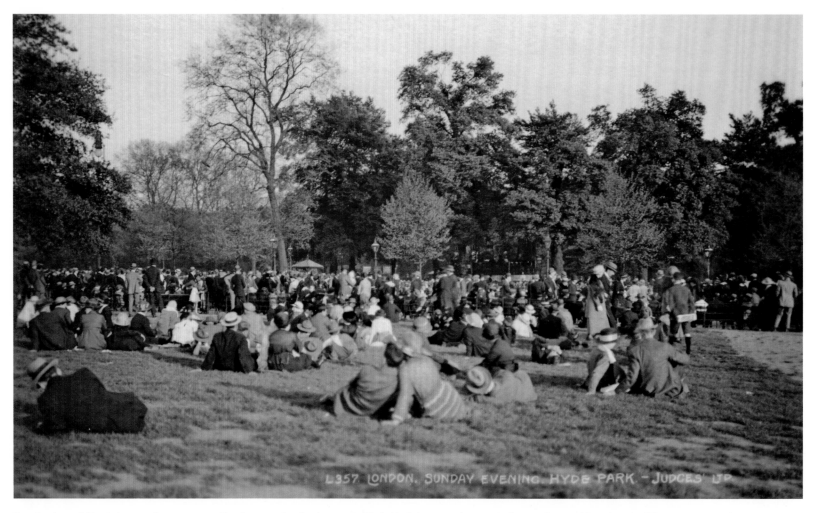

L357 LONDON. SUNDAY EVENING. HYDE PARK. – JUDGES' LTD

People chat while sitting on the grass on a Sunday evening in the 1930s. Hyde Park is a popular venue for tourists and Londoners alike.

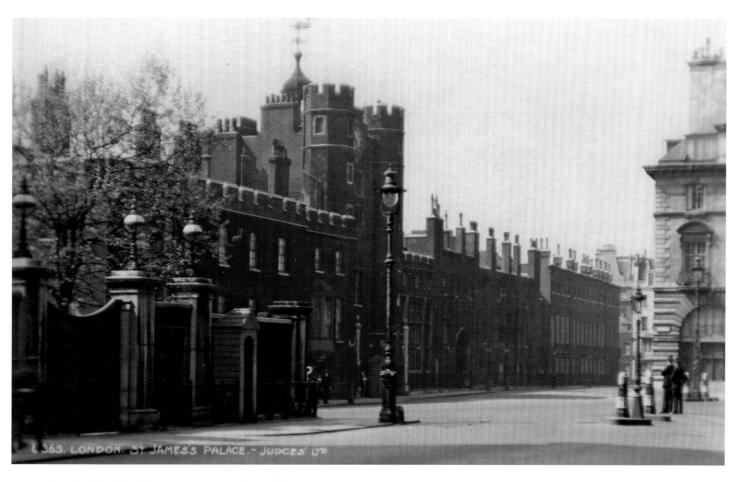

L 363. LONDON. ST JAMES'S PALACE. - JUDGES' LTD

St James's Palace has been home to our monarchs until Queen Victoria ascended the throne in 1837. Built in the 1530s, the palace is now used for state functions; the offices of Princes William and Harry are here. It is a tradition that foreign ambassadors are sworn in here, giving them the title of 'Ambassadors to the Court of St James's.'

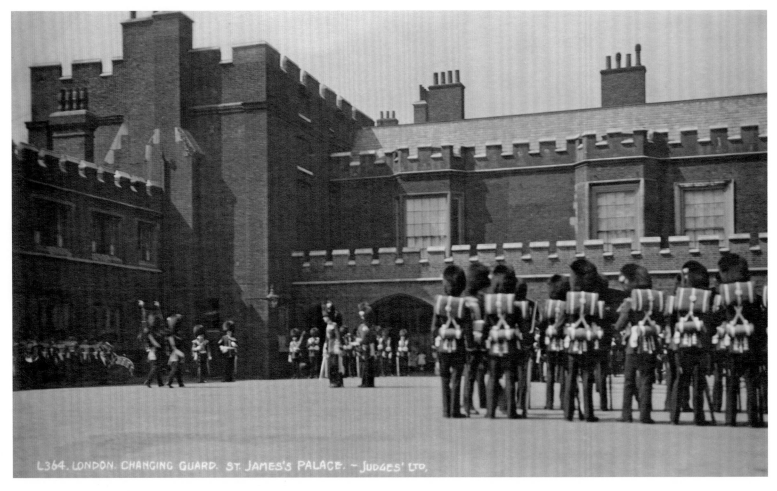

L364. LONDON. CHANGING GUARD. ST. JAMES'S PALACE. – JUDGES' LTD.

The Changing of the Guard at St James's Palace takes place in Friary Court. Having marched from Buckingham Palace, we see the new guard about to go on duty. They carry their folded greatcoats and rolled blankets on their backs, a tradition that was faded out in the 1930s.

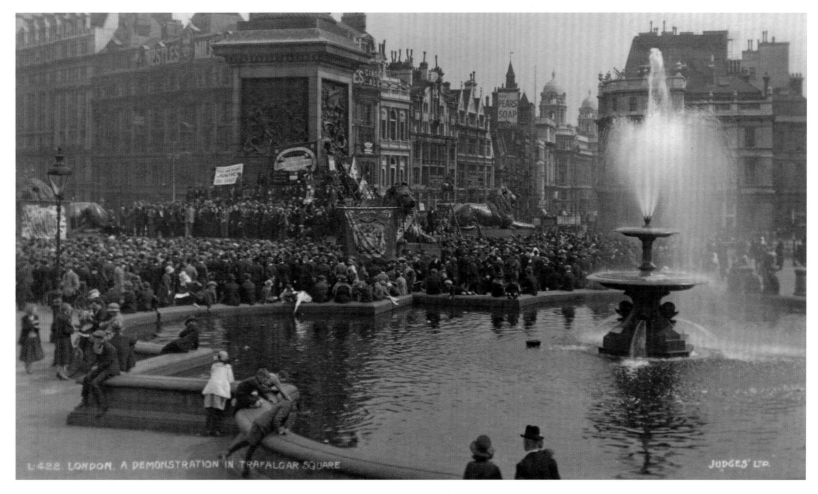

L.422 LONDON. A DEMONSTRATION IN TRAFALGAR SQUARE JUDGES' LTD.

Trafalgar Square, the scene of political demonstrations since the nineteenth century. Religious and cultural festivals are often held here on weekends; this famous rendezvous is a draw for thousands of people to gather for New Year celebrations, being within earshot of Big Ben.

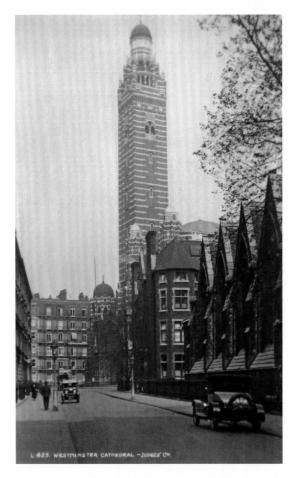

Westminster Cathedral is the mother church to the Catholic religion in England and Wales. It is also the largest Catholic place of worship in the country. Built between 1895 and 1903 the tower, 202 feet above street level, gives spectacular views over London.

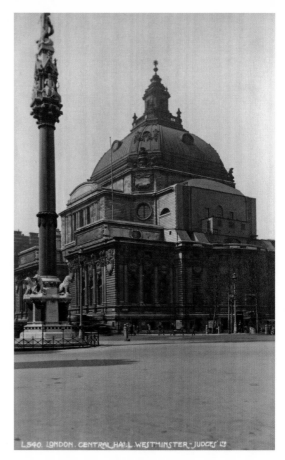

Central Hall, one of the world's largest purpose-built conference centres, is home to Westminster's Methodist congregation. Its roof was used for filming scenes in 2011 when Prince William and Kate Middleton were married in Westminster Abbey opposite. The column is the Crimean War Memorial.

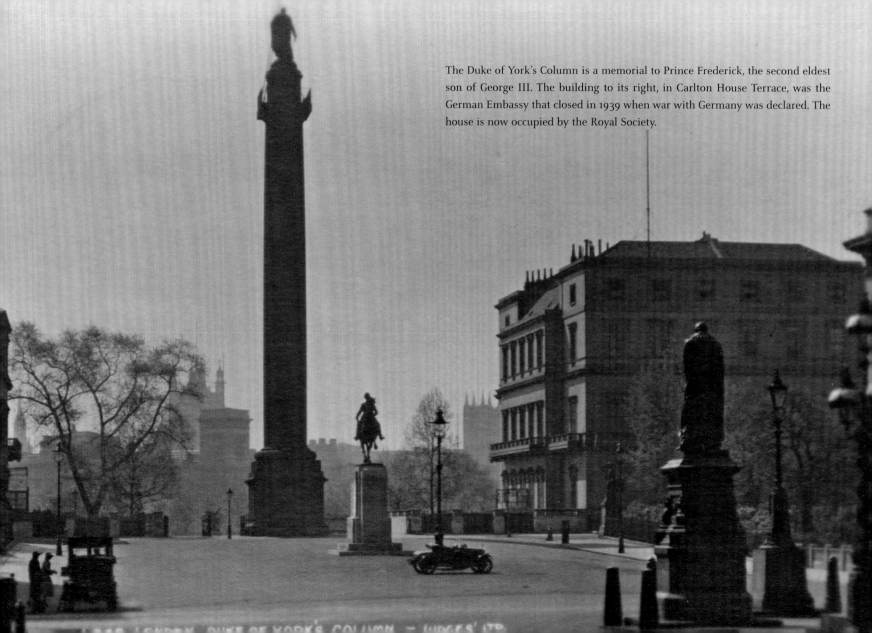

The Duke of York's Column is a memorial to Prince Frederick, the second eldest son of George III. The building to its right, in Carlton House Terrace, was the German Embassy that closed in 1939 when war with Germany was declared. The house is now occupied by the Royal Society.

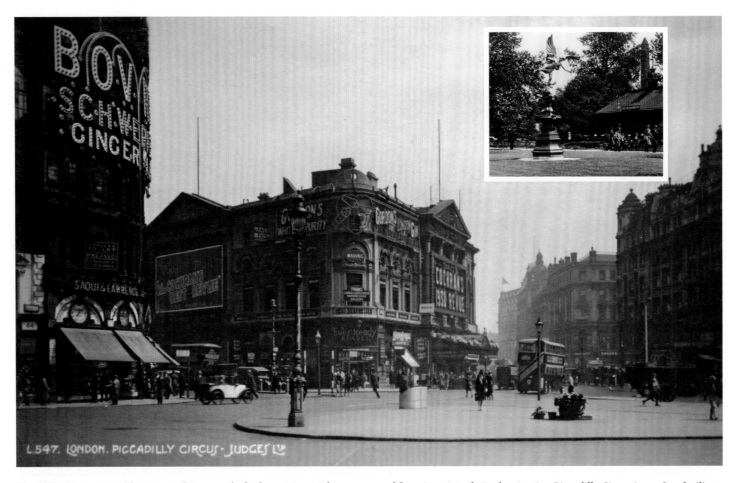

Piccadilly Circus, 1930. The statue of Eros, or Shaftesbury Memorial, was removed from its original site dominating Piccadilly Circus in 1928 to facilitate the rebuilding of the new Piccadilly underground station ticket hall. The inset photograph, not by Judges, shows its temporary home in Embankment Gardens close to Cleopatra's Needle.

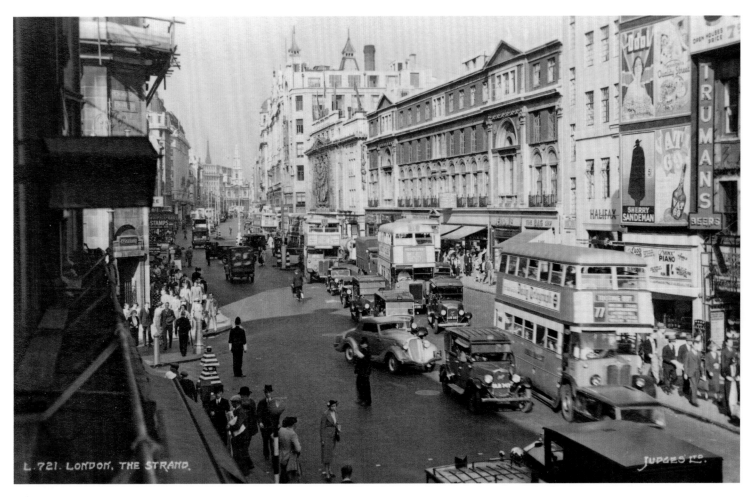

The Strand looking east in the late 1930s. Just beyond the corner door on the left is Stanley Gibbons, the world-famous stamp dealer who still occupies the site. In the very distance you can just see the St Clement Danes Church, and to its left is the tall spire of the Royal Courts of Justice.

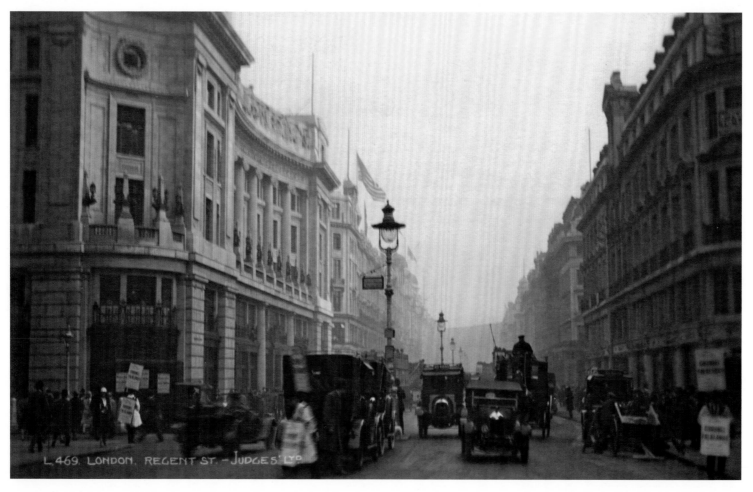

Regent Street seen from Oxford Circus. On the roof of Dickens & Jones department store is the American flag flying at half-mast . The author could not find any reason for this except to possibly mark the death of President Warren G. Harding who died on 2 August 1923 while still in office.

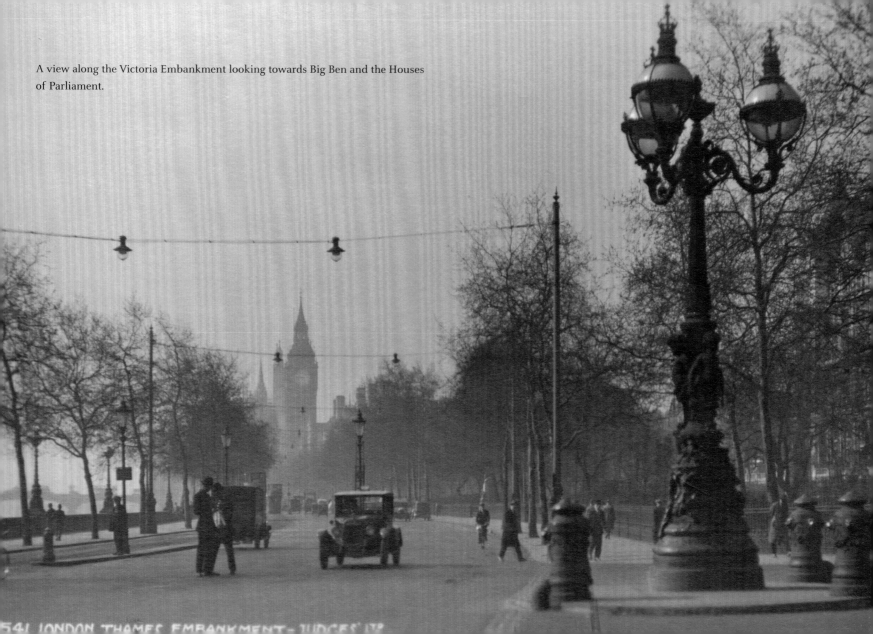

A view along the Victoria Embankment looking towards Big Ben and the Houses of Parliament.

541 LONDON THAMES EMBANKMENT - JUDGES' LTD

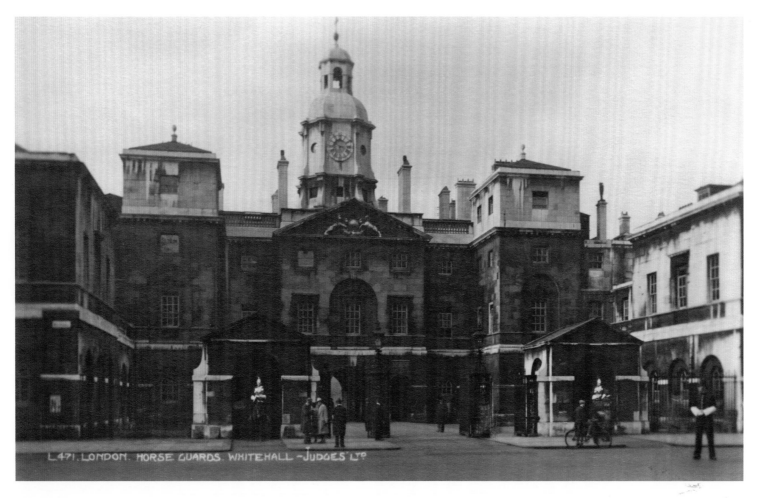

L.471. LONDON. HORSE GUARDS. WHITEHALL –JUDGES LT?

Horse Guards in the 1940s. This was once the headquarters of the commander-in-chief of the British Army. The building is well known for the sentries who guard the entrance to Horse Guards Parade where the Changing of the Guards ceremony takes place every day.

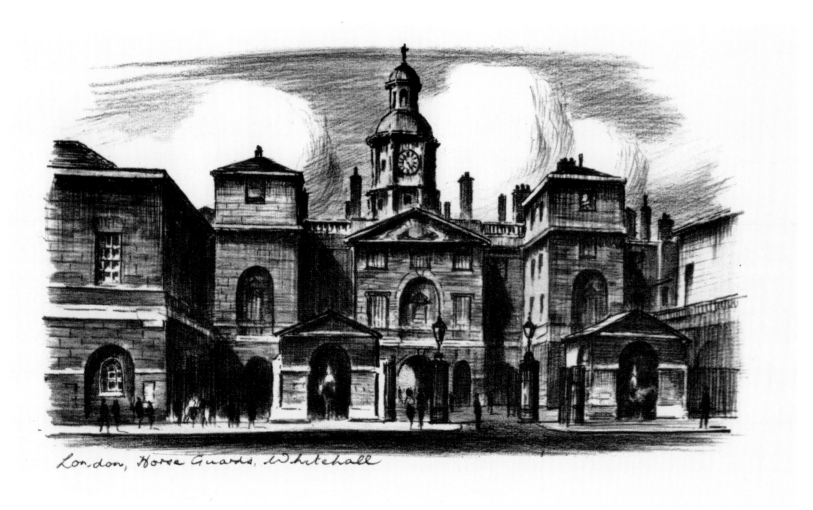

London, Horse Guards, Whitehall

Colour sketch by W. H. Constantine and reissued as a postcard in the 1960s.

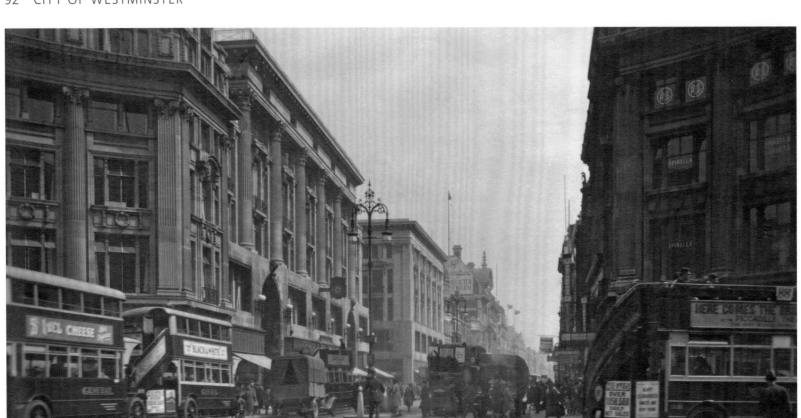

L.544. LONDON. OXFORD STREET - JUDGES' L^{TD}

Oxford Circus in the 1920s looking towards Tottenham Court Road. Oxford Circus underground station is to the right-hand side. The building on the corner of Oxford Street and Regent Street is the London headquarters of the corset company Spirella. Their products were not sold in shops; instead female corsetières were sent to their customers' homes.

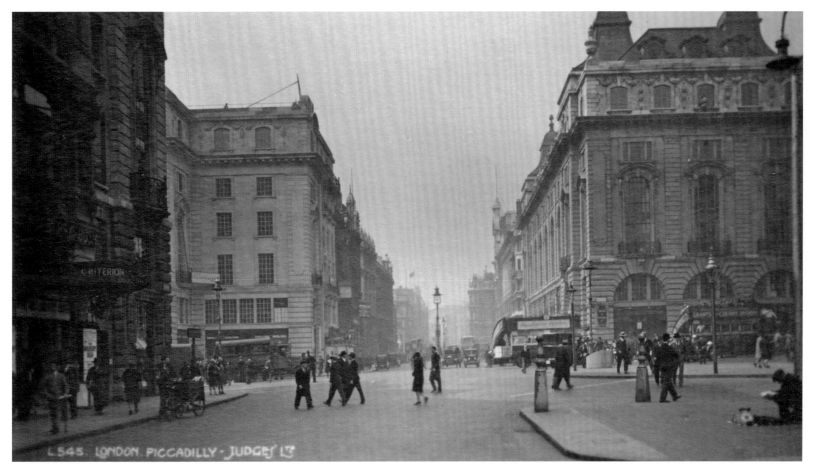

L545. LONDON. PICCADILLY - JUDGES LTD

It is sometimes said that the name Piccadilly stems from the word piccadill, a decorative lace collar popular in the sixteenth and seventeeth centuries, manufactured by Robert Baker in Piccadilly. In this once elegant street are Fortnum & Mason, the royal grocery shop, Hatchards, the oldest bookshop in London patronised by HM the Queen, Burlington Arcade, the world's first shopping mall of 1819 and the Royal Academy of Arts.

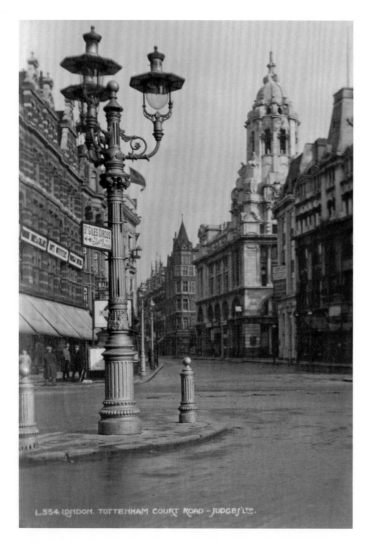

L.554. LONDON. TOTTENHAM COURT ROAD – JUDGES LTD.

Left: Tottenham Court Road, *c.* 1925. An attractive gas lamp dominates this empty thoroughfare once renowned for its furniture stores and now for its electronic outlets.

Opposite: Elegantly curved Regent Street designed for the Prince Regent, crowned George IV in 1820. This thoroughfare runs between Regent's Park and Carlton House Terrace close to Pall Mall.

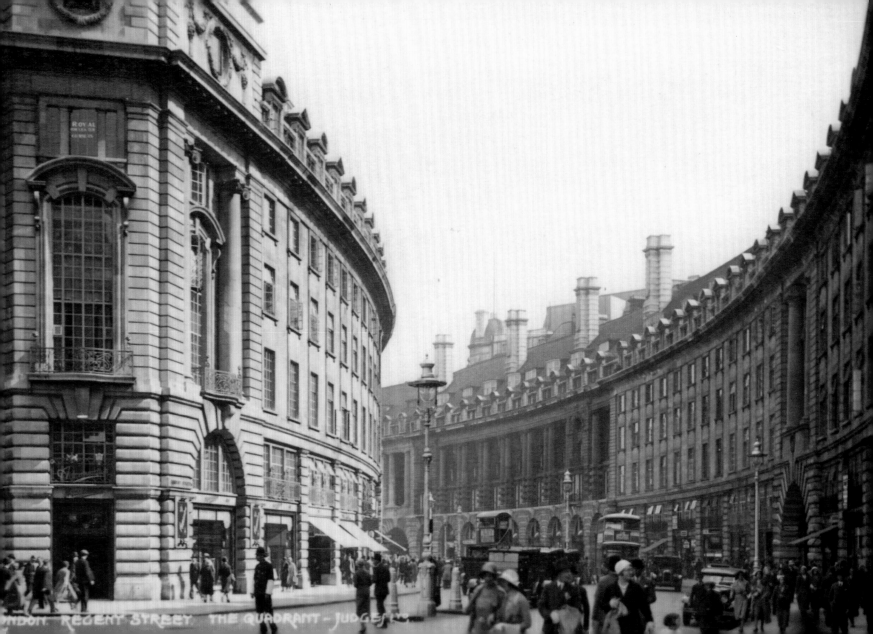

LONDON. REGENT STREET. THE QUADRANT - JUDGES LTD

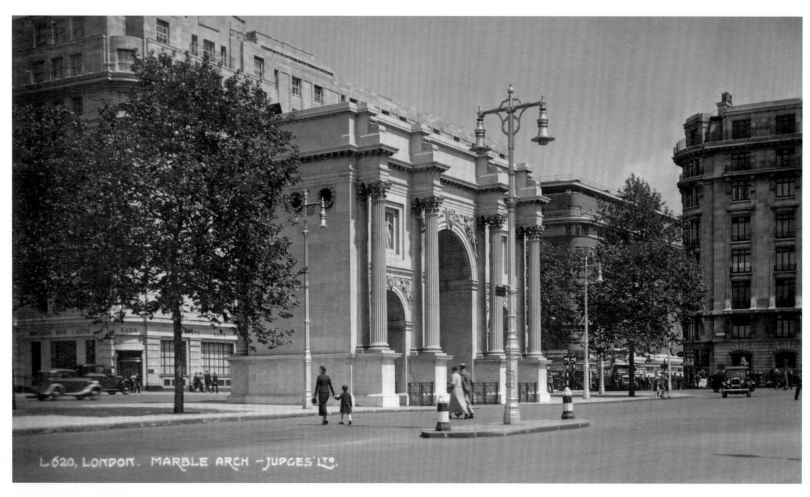

L.620, LONDON. MARBLE ARCH — JUDGES' LTD.

Marble Arch in the 1950s. This grand arch was built to resemble the Arch of Constantine in Rome. It stands near the site of the infamous Tyburn tree that was once a notorious public execution site. A plaque set into a traffic island nearby reminds us of the gruesome events that took place there from 1196 to 1783.

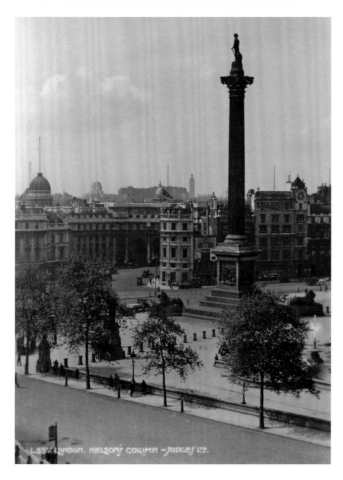

Nelson's Column commemorates Lord Viscount Horatio Nelson's victory over the combined French and Spanish fleets at the Battle of Trafalgar in 1805. Unfortunately Lord Nelson was killed by a sniper's bullet at the height of the battle. He lies buried in St Paul's Cathedral in the City of London.

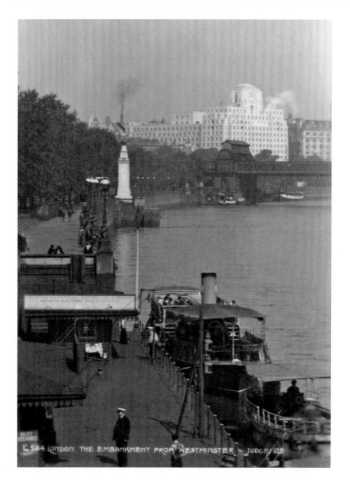

Westminster Pier where visitors board tourist boats for cruises along the river. The Royal Air Force Memorial is clearly visible, as is the large white building, Shell-Mex House, that was once headquarters of Shell and British Petroleum. The clock built into the tower is the largest in London.

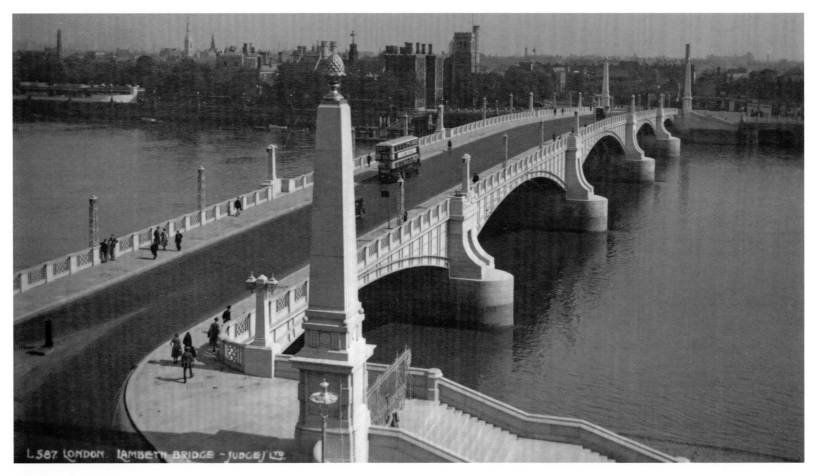

L 587 LONDON LAMBETH BRIDGE – JUDGE'S LTD.

Lambeth Bridge, the most elegant bridge over the Thames, was opened by George V in 1932. The obelisks on the corners are topped by pineapples to remind us that John Tradescant, the famed horticulturist, first introduced pineapples to England in the seventeenth century. He is buried in nearby St Mary's Church, now the Museum of Garden History.

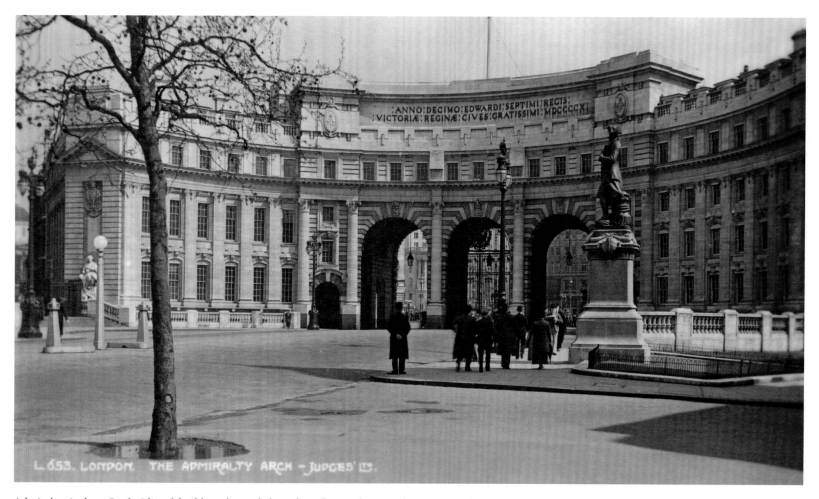

L. 653. LONDON. THE ADMIRALTY ARCH - JUDGES' LTD.

Admiralty Arch, a Grade I-listed building, housed the Admiralty until 1994. The statue to the right at the entrance to The Mall is of Captain James Cook, the eighteenth-century British explorer and navigator.

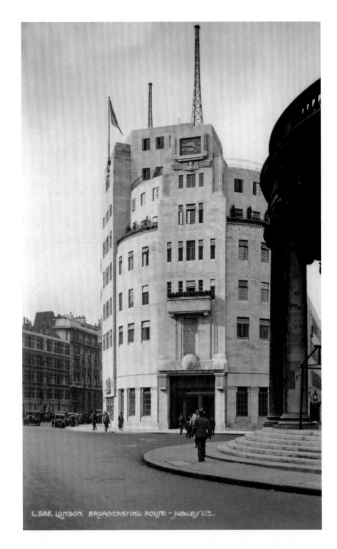

L.585. LONDON. BROADCASTING HOUSE - JUDGES LTD.

Left: This iconic Art Deco building is the world headquarters of the British Broadcasting Corporation. The empty niche above the entrance will house the statues of Ariel and Prospero, characters from Shakespeare's *The Tempest*. The work was carried out by the controversial sculptor Eric Gill.

Opposite: Buckingham Palace has been the official residence of our monarchs since the reign of Queen Victoria, 1837–1901. With more than 700 rooms, the Royal Standard is seen flying over the palace indicating that the monarch is at home. When she is not in residence the Union flag replaces the Royal Standard. In the foreground is the Queen Victoria Memorial.

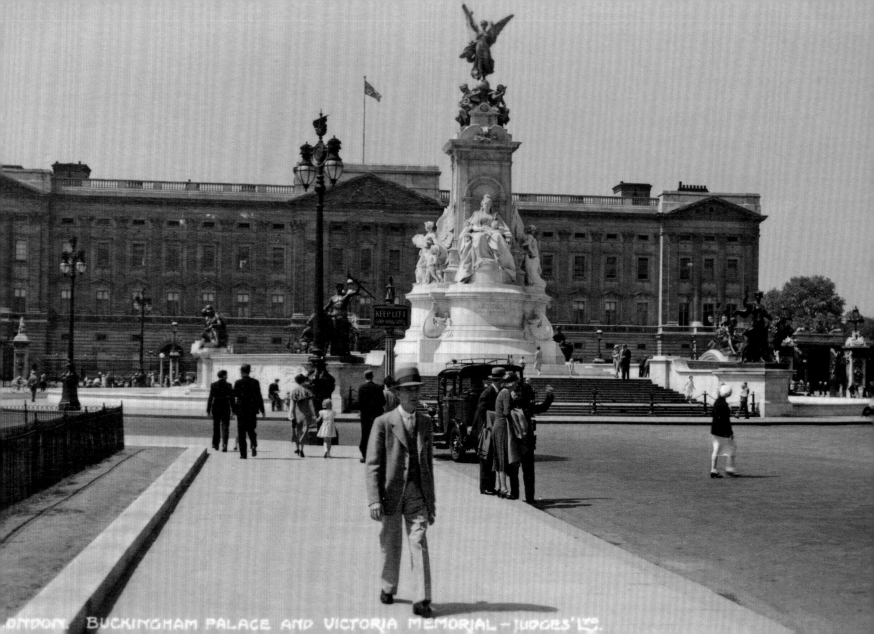

LONDON. BUCKINGHAM PALACE AND VICTORIA MEMORIAL - JUDGES' LTD.

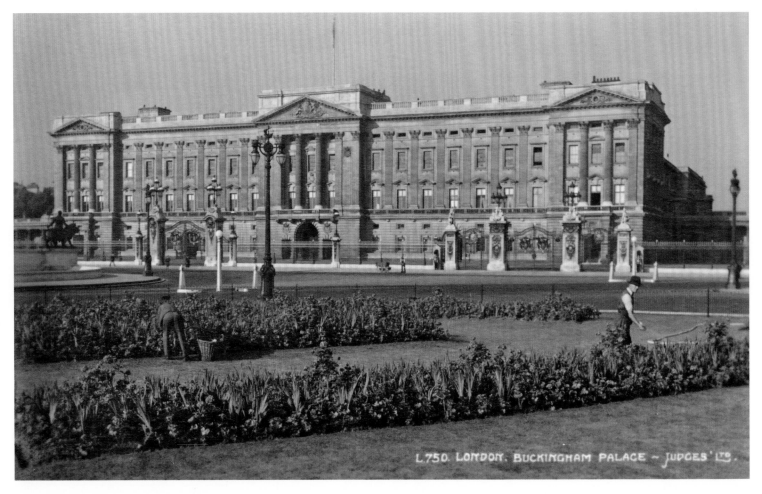

The Victoria Gardens in front of Buckingham Palace are a blaze of colour in the spring and summer. Here we see two gardeners busy at work tending to the flowers and shrubs.

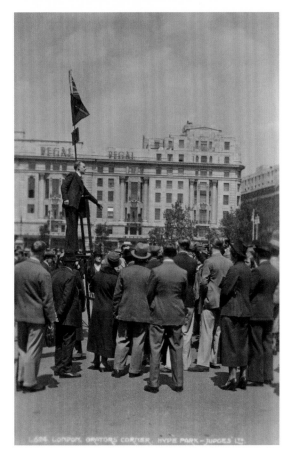

Speakers' Corner is where people have gathered since 1872 to take part in discussions if considered lawful by the police. Here we see an orator in the 1930s who has attended a large crowd of listeners. Speakers' Corner is at the north-east corner of Hyde Park near Marble Arch and Oxford Street.

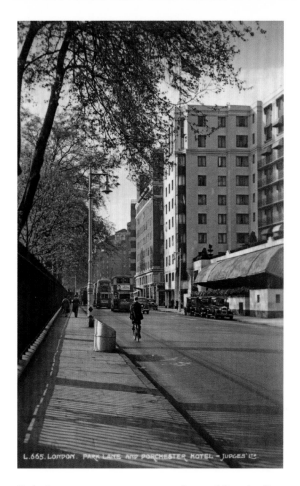

Park Lane was once a narrow thoroughfare leading from Hyde Park Corner to Marble Arch. Today it is one of the busiest and widest roads in central London. On the right is the Dorchester Hotel on the western edge of Mayfair, one of London's most exclusive areas.

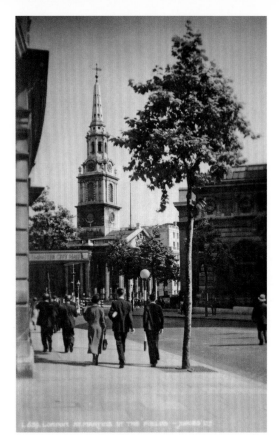

St Martin-in-the-Fields Church seen from Charing Cross Road. In 1825 King Kamehameha II of Hawaii, with his wife and entourage, visited London for a state visit. The king unfortunately contracted measles and died. His wife died six days later and their bodies were stored in the crypt until they were transported back to Honolulu for burial.

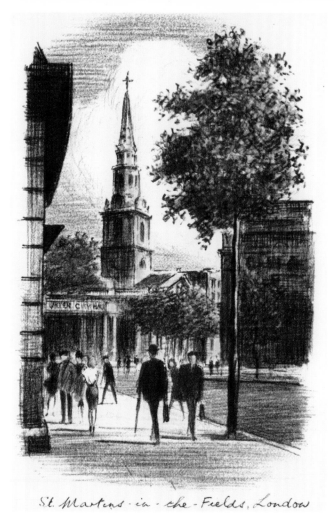

St. Martins·in·the·Fields, London

Colour sketch by W. H. Constantine and reissued as a postcard in the 1960s.

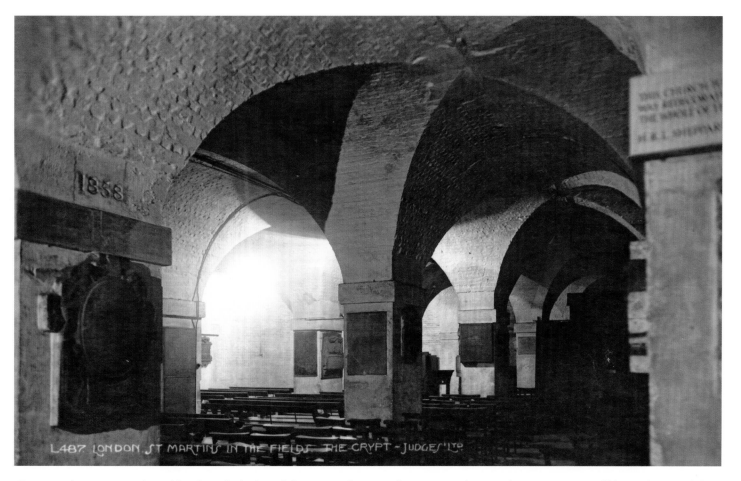

L487 LONDON ST MARTINS IN THE FIELDS THE CRYPT - JUDGES LTD

The crypt of St Martin-in-the-Fields where the bodies of the King and Queen of Hawaii were kept until arrangements could be made to send them home for burial. Tucked away is an excellent brass rubbing centre, and breakfast or lunch is available in Café in the Crypt, a self-service restaurant popular with Londoners and visitors alike.

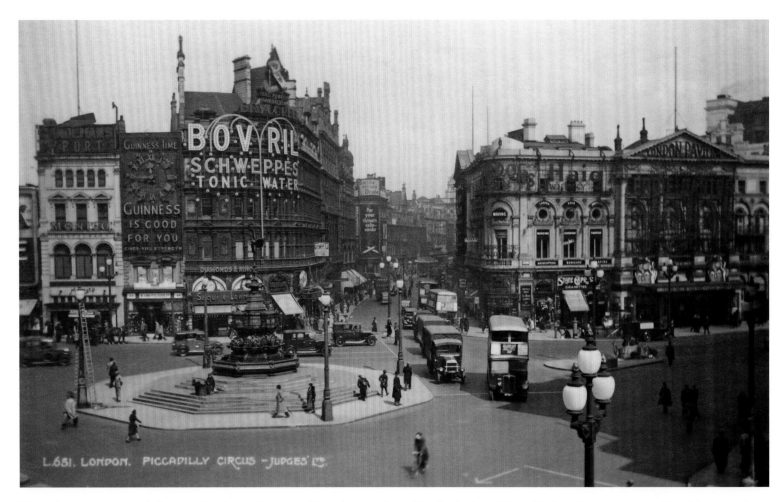

Piccadilly Circus in 1937. A flower-seller sits on the steps of Eros, known also as The Shaftesbury Memorial. A workman props up his ladder to tend to a street lamp and commuters rush to and from work.

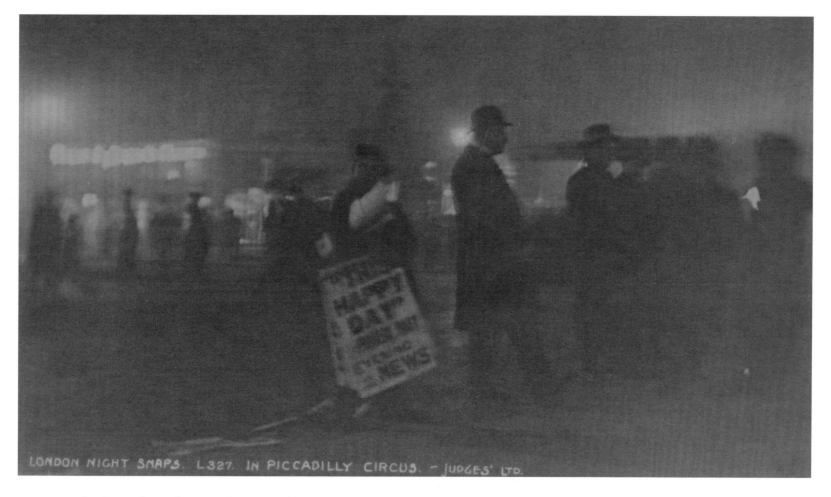

LONDON NIGHT SNAPS. L327. IN PICCADILLY CIRCUS. - JUDGES' LTD.

A rare example of a London Night Snap. This is one of a series of fifty images photographed at night by Fred Judge; it is thought he may have used a miniature camera. These went into production after the First World War but were never sold as postcards.

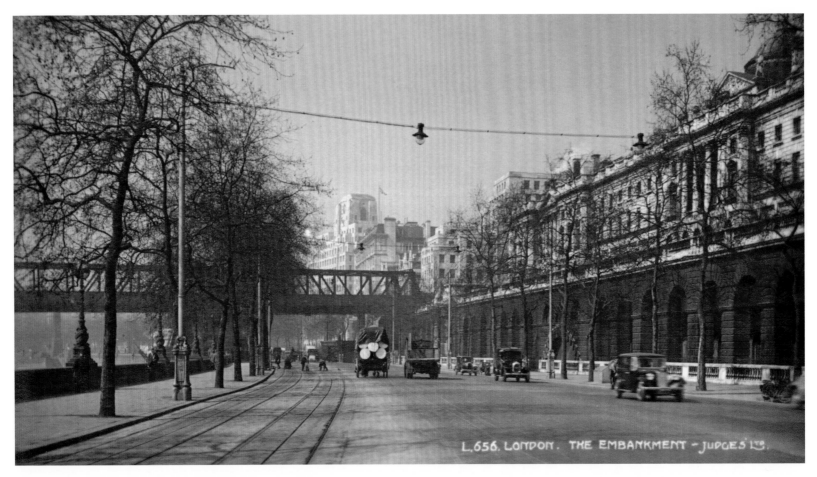

L.656. LONDON. THE EMBANKMENT – JUDGES LTD.

Until the 1850s the River Thames stretched to the walls of Somerset House on the right. London's waste was fed into the Thames through ancient pipes causing cholera and death. In the 1850s and '60s land was reclaimed from the river and a vast sewerage system was constructed beneath the newly built Embankment. Over 100 miles of new pipes diverted waste to sewage works east of London.

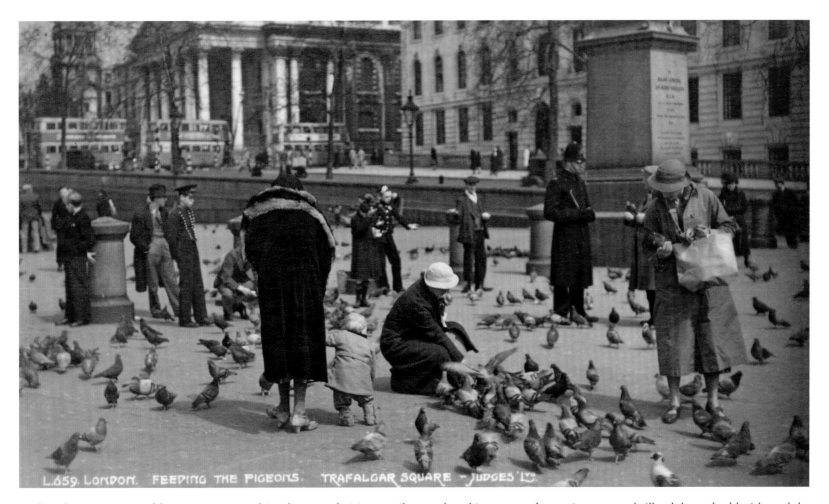

L.659. LONDON. FEEDING THE PIGEONS. TRAFALGAR SQUARE – JUDGES LTD.

Feeding the pigeons in Trafalgar Square attracted Londoners and visitors until 2003 when this very popular pastime was made illegal due to health risks and the rising costs of cleaning the square and surrounding buildings.

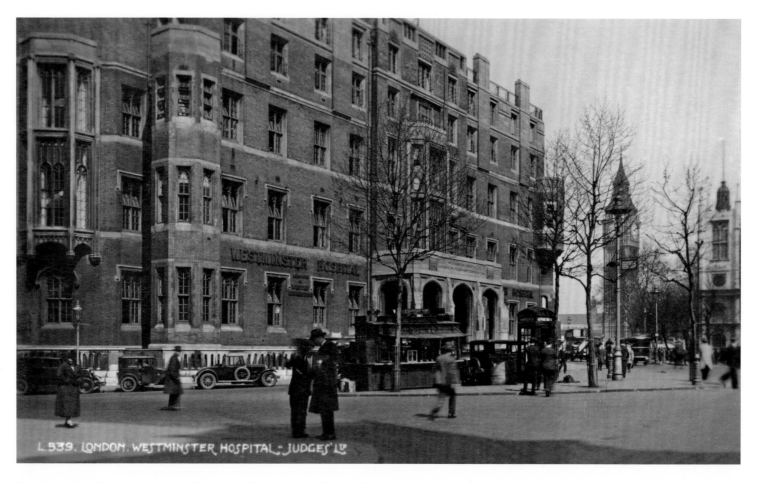

L 539. LONDON. WESTMINSTER HOSPITAL - JUDGES LTD

The pioneering Westminster Hospital once stood opposite the Abbey and Parliament Square. The hospital was opened in 1834 and could accommodate up to 200 inpatients. In 1950 the building was pulled down to make way for the Queen Elizabeth II Conference Centre and the hospital was moved to Horseferry Road.

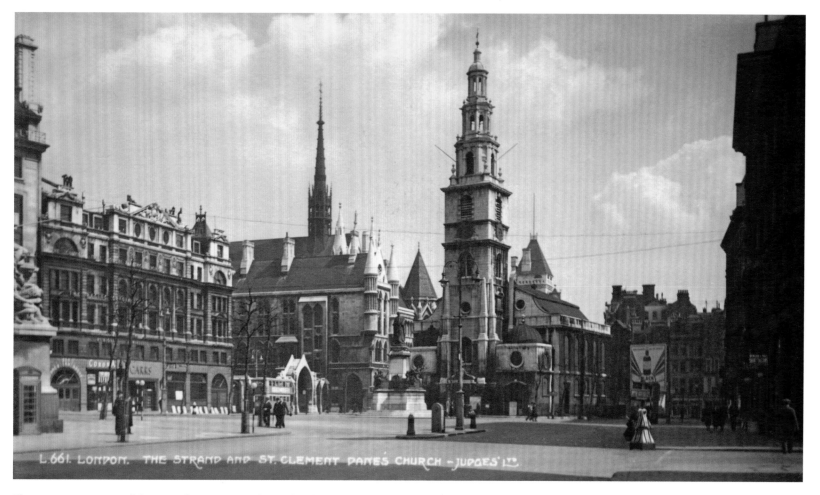

L.661. LONDON. THE STRAND AND ST. CLEMENT DANES CHURCH - JUDGES' LTD.

The eastern extremity of the City of Westminster; beyond is the historic City of London. St Clement Danes Church, the Royal Air Force church, stands on an island in the Strand. Beyond the shops are the Royal Courts of Justice, the largest court building in Europe dealing with cases of civil law.

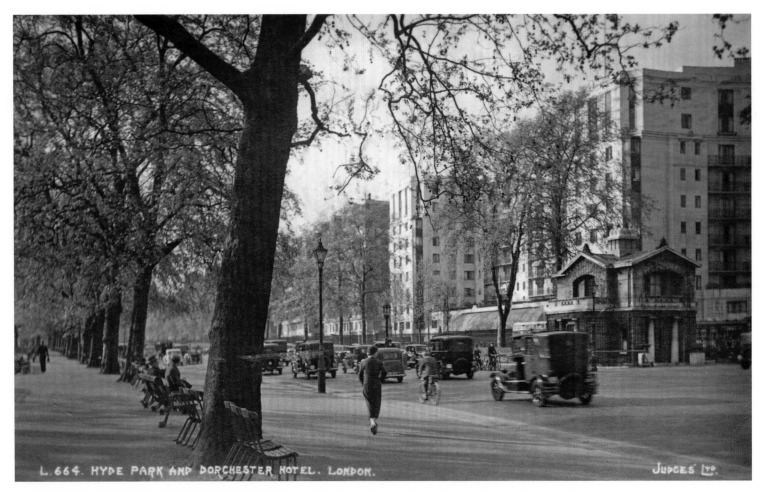

L.664. HYDE PARK AND DORCHESTER HOTEL. LONDON.

JUDGES LTD.

Park Lane and the newly built Dorchester Hotel. This luxurious five-star hotel, a short distance from Hyde Park, has had close ties to the rich and famous since its opening in the 1930s. Prince Phillip held his stag night (bachelor party) here in 1947 before his marriage to Princess Elizabeth, now Elizabeth II.

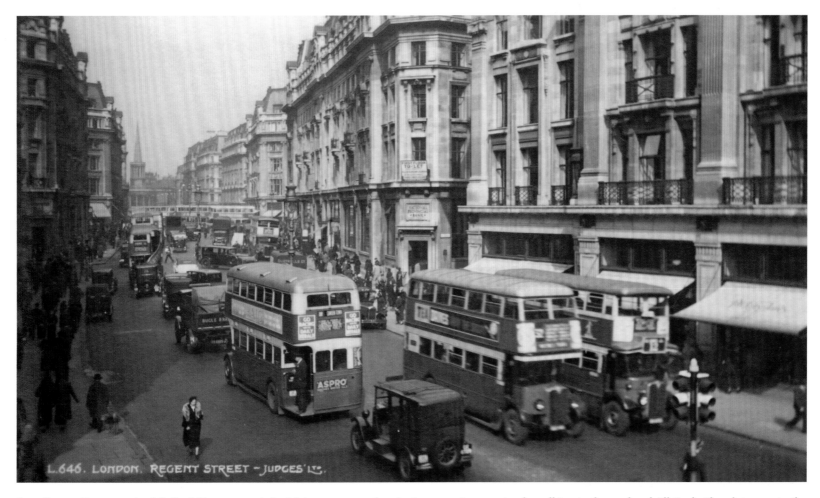

Busy Regent Street north of Oxford Circus, crowded with buses, cars and taxis. A woman is precariously walking in the road and All Souls Church is seen in the far distance.

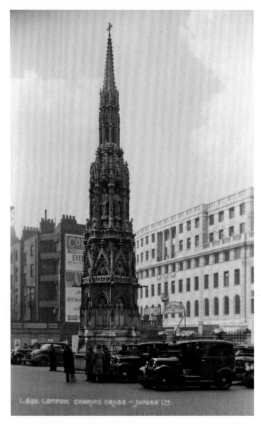

In the forecourt of Charing Cross railway station is the memorial to Eleanor of Castile, wife of Edward I, who died in 1290. Her body was brought to Westminster Abbey for burial. At each place where the body rested overnight Edward built a memorial cross, and this replica, one of twelve, was her last resting place before reaching the Abbey.

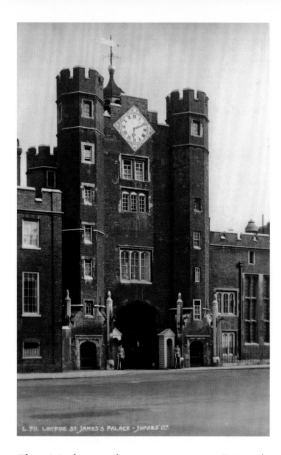

The original sixteenth-century entrance to St James's Palace, built during the reign of Henry VIII on the site of a leper colony. Although no longer lived in, it still functions as the official palace of the royal family. Here major functions and banquets take place. It was the temporary home of Prince Charles after his divorce from Diana Princess of Wales.

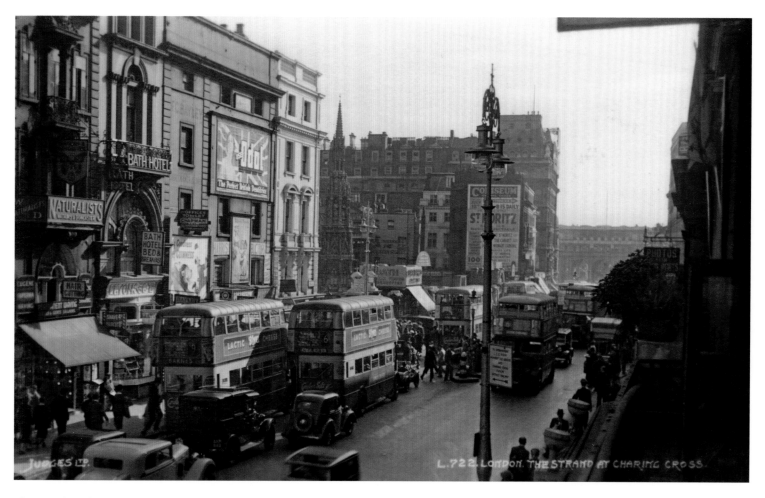

The Strand at Charing Cross in the late 1930s. The Eleanor Cross peeps out from the buildings on the left. Lyons, a popular tea shop, is open, and next door a barber is offering shaves for 4*d* and haircuts for 8*d*. Odol, a popular German mouthwash, is advertised bearing the Union Flag design.

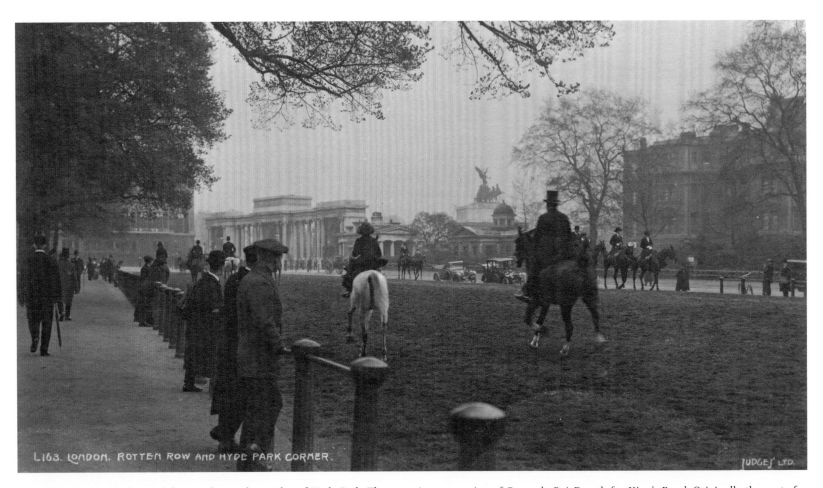

L163. LONDON. ROTTEN ROW AND HYDE PARK CORNER.

JUDGES LTD.

Rotten Row is a wide thoroughfare on the southern edge of Hyde Park. The name is a corruption of *Route du Roi*, French for King's Road. Originally the route for William III to Kensington Palace, by the eighteenth century it became a fashionable venue for the nobility to promenade. Today it is a safe place for horse riding in the centre of London.

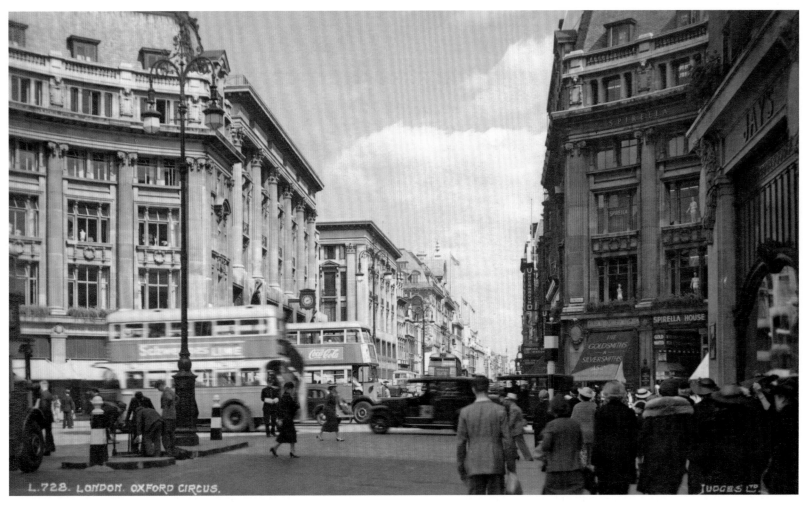

Oxford Circus is where Oxford Street and Regent Street converge. This very popular area is in the heart of London's busiest shopping district.

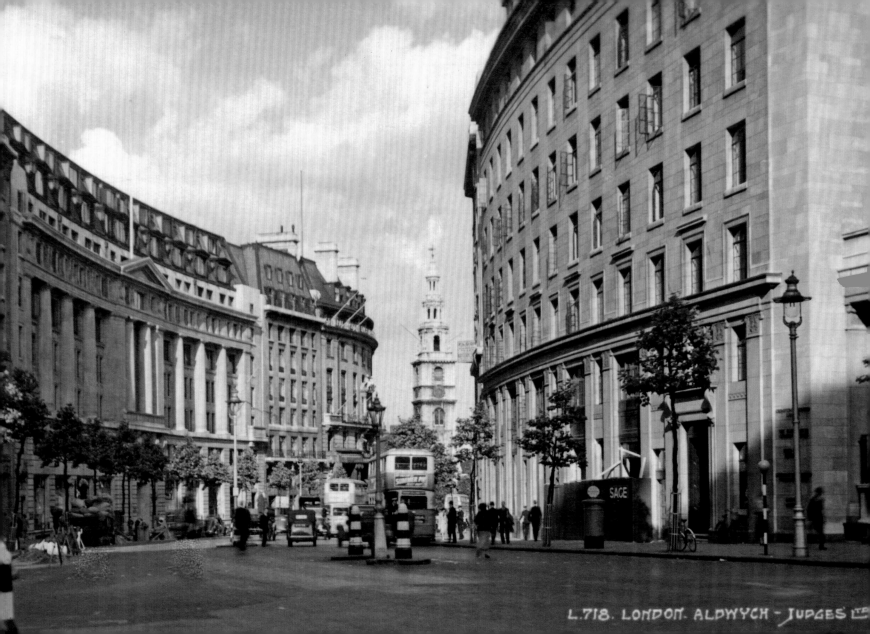

L.718. LONDON. ALDWYCH - JUDGES LTD

Right: A soldier of the Household Cavalry on duty in Whitehall in the 1940s. There are two mounted regiments that act as the monarch's personal bodyguard. They are highly professional soldiers in the British Army.

Opposite: At the eastern edge of Westminster is a crescent-shaped thoroughfare called Aldwych that takes its name from the Anglo-Saxon word *Ludenwic* meaning 'old trading settlement'. Today Aldwych is home to the luxurious Waldorf Astoria Hotel and the High Commissions for India and Australia.

The soldiers and drummers of HM Coldstream Guards march from Buckingham Palace to St James's Palace as crowds of onlookers watch the Changing of the Guard ceremony in the 1940s.

LONDON. CHANGING THE GUARD. BUCKINGHAM PALACE. JUDGE

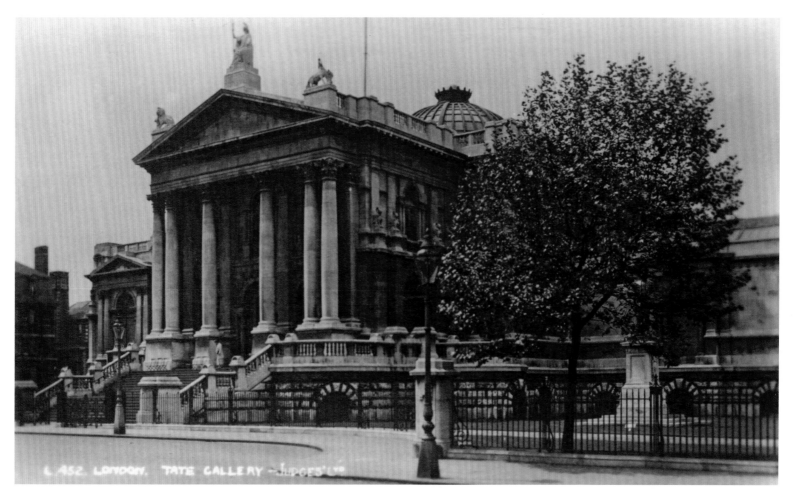

The Tate Gallery, built on the site of the infamous Millbank Penitentiary, is today an art gallery that exhibits an English collection of art from the sixteenth to the early nineteenth century. Its sister gallery, the Tate Modern, holds the international collection of modern art.

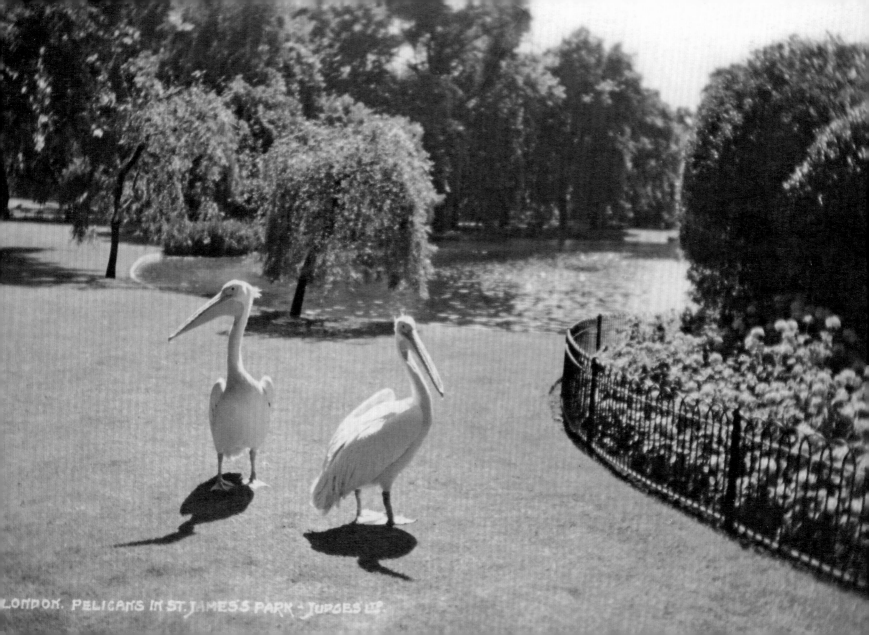

LONDON. PELICANS IN ST. JAMES'S PARK - JUDGES LTD.

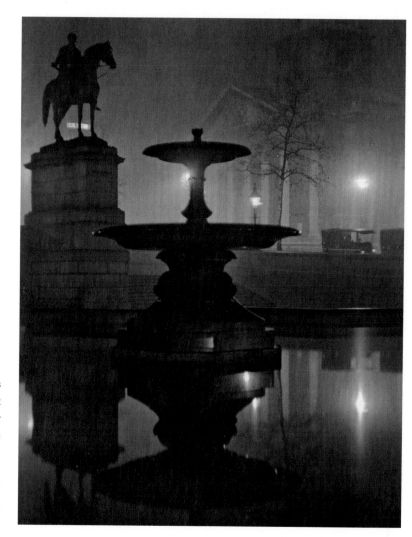

Right: This dramatic photograph taken around 1910 demonstrates the skills needed for night photography. Shown is one of the large fountains that dominates Trafalgar Square. The fountains were built in 1845 to decrease floor space that might be used for demonstrations here. Newly invented steam pumps drew water up from artesian wells beneath the ground.

Opposite: Pelicans were given to Charles II as a gift by the Russian ambassador in 1664 and they have always lived in St James's Park. Today, over forty pelicans entertain visitors and they can be seen in the lake on Pelican Rock.

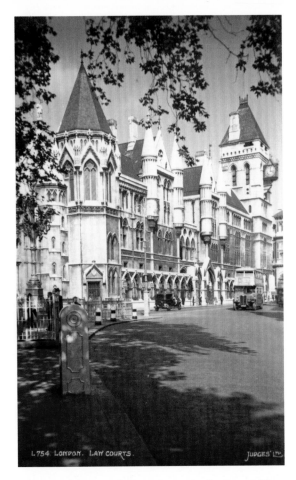

A bus rumbles past the Law Courts in the Strand. They opened for business in the 1880s and the building was designed by G. E. Street, an eminent architect who specialised in the design of churches – hence its austere Gothic appearance.

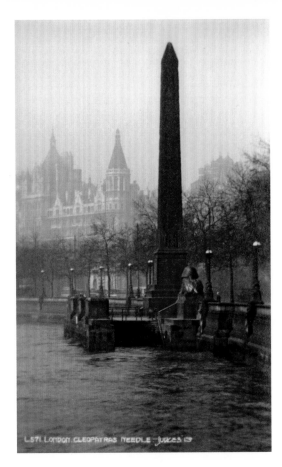

Cleopatra's Needle is London's oldest monument, presented as a gift by the Turkish envoy to Egypt in 1819. Buried beneath is a time capsule containing coins, cigarette packets, newspapers and the images of twelve of the most beautiful English women of 1819.

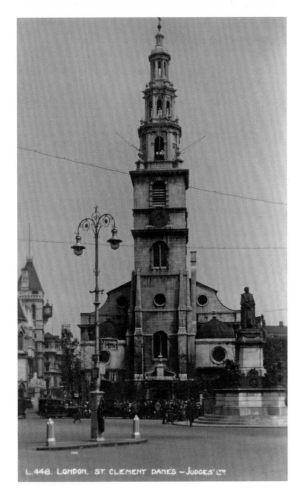

At the eastern edge of the City of Westminster stands St Clement Danes Church. To its left are the Royal Courts of Justice. In 1958 the church was completely restored to become the Central Church of the Royal Air Force.

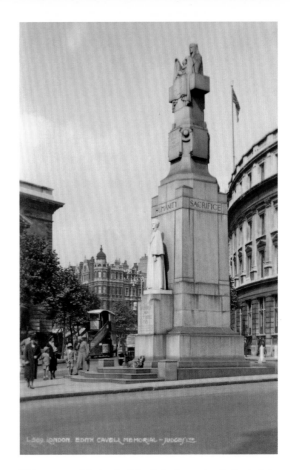

This memorial, in St Martin's Lane, is dedicated to Nurse Edith Cavell, an English nurse working in Belgium when the First World War broke out in 1914. She was arrested for aiding British soldiers to escape from German-occupied Belgium, and was executed on 12 October 1915.

ACKNOWLEDGEMENTS

This book would have not been possible without the valuable help of Trevor Wolford of Judges Sampson Ltd. who gave me permission to use the photographic postcards in this book. I also thank Max and Conner of Judge Sampson Ltd. for their expert help with the reproduction of some of the images in this book. I am indebted to the National Motor Museum at Beaulieu, London Transport Museum and the London Vintage Taxi Association for their invaluable help in identifying vehicles for the purposes of dating some of the photographs. Westminster City Archives and Westminster City Council have been an invaluable source of reference throughout, and of course, the worldwide web that allowed me to work through the night without disturbing anyone at all.

I am indebted to the Institute of Tourist Guiding for their permission for me to use the Blue Badge symbol. Thank you also fellow Blue Badge guides for your expert help and advice.

A big hug to Molly, my dear wife, who bullied and badgered me along the way. To Jenny, my editor, and those at Amberley Publishing for their professionalism to make this book possible.

BIBLIOGRAPHY

Bradley, Simon and Nikolaus Pevsner, *The Buildings of England: Westminster* (Yale University Press)

Georgano, G. N., *A History of the London Taxi Cab* (David and Charles)

Weinreb, Ben and Christopher Hibbert (eds.), *The London Encyclopaedia* (Macmillan)

Also Available from Amberley Publishing

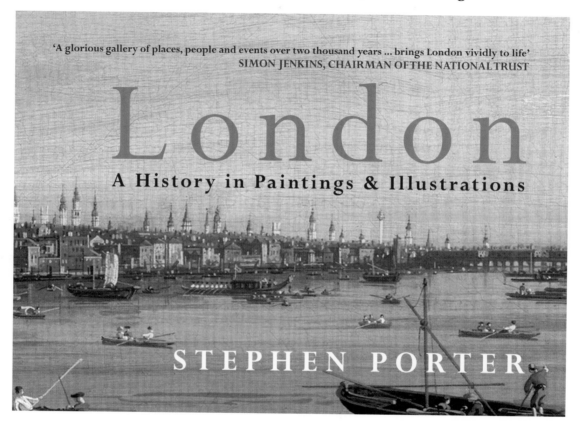

'A glorious gallery of places, people and events over two thousand years ... brings London vividly to life'
SIMON JENKINS, CHAIRMAN OF THE NATIONAL TRUST

London

A History in Paintings & Illustrations

STEPHEN PORTER

978-1-4456-3274-2